BILSTON, BRADLEY & LADYMOOR

A SEVENTH SELECTION

RON DAVIES

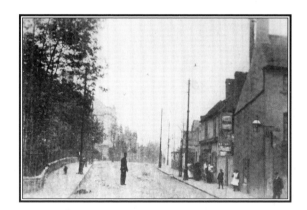

Title page: An old view of Mount Pleasant.

First published 2011

The History Press
The Mill, Brimscombe Port
Stroud, Gloucestershire, GL5 2QG
www.thehistorypress.co.uk

British Library Cataloguing in Publication Data.
A catalogue record for this book is available from the British
Library.

ISBN 978 0 7524 6609 5

Typesetting and origination by The History Press
Printed in Great Britain

CONTENTS

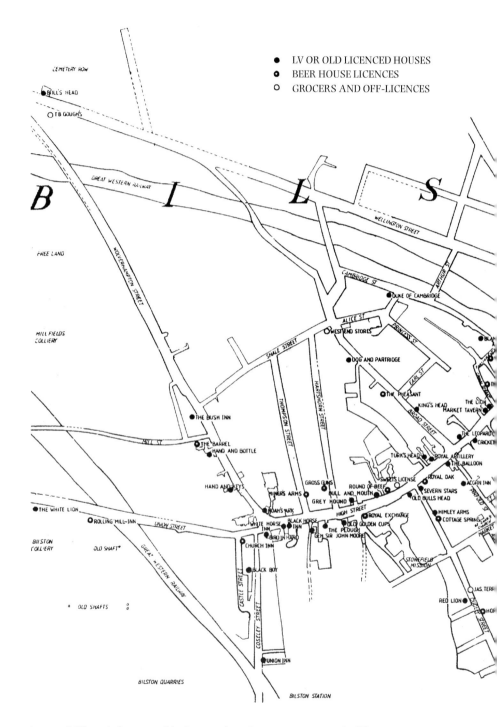

A map of Bilston's former public houses, beer houses, grocers and off-licences, *c.* 1895.

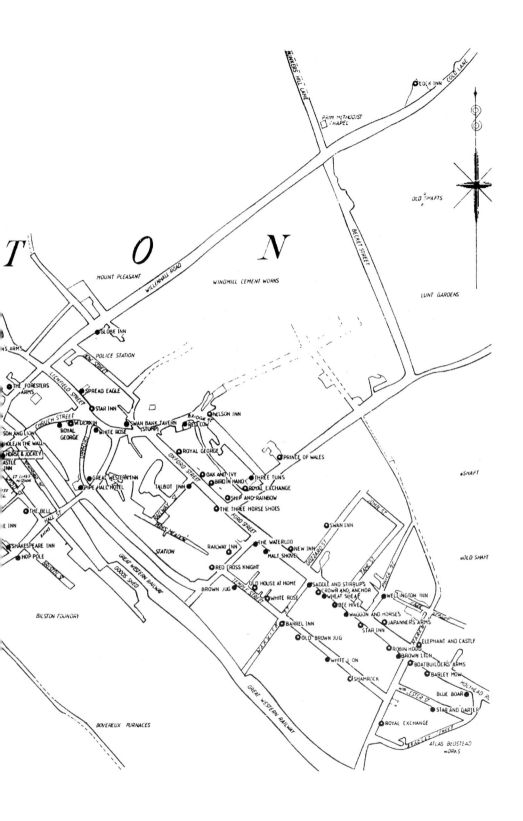

T O N

COCK INN

PRIM METHODIST CHAPEL

BUNKERS HILL LANE

COLD LANE

BECKET STREET

OLD SHAFTS

MOUNT PLEASANT

WILLENHALL ROAD

WINDMILL CEMENT WORKS

LUNT GARDENS

GLOBE INN

POLICE STATION

FOX STREET

LICHFIELD STREET

THE FORESTERS ARMS

SPREAD EAGLE

STAR INN

CHURCH STREET

W. DERKIN

SON AND LION

ROYAL GEORGE

WHITE ROSE

SWAN BANK TAVERN (STUMP)

BRIDGE ST

NELSON INN

RED COW

HOLE IN THE WALL

HORSE & JOCKEY

ROYAL GEORGE

PRINCE OF WALES

ASTLE INN

SHAFT

OXFORD STREET

GREAT WESTERN INN

PIPE HALL HOTEL

TALBOT INN

OAK AND IVY

BIRD IN HAND

THREE TUNS

ROYAL EXCHANGE

SHIP AND RAINBOW

THE BELL

HALL ST

THE THREE HORSE SHOES

FORD STREET

SWAN INN

JOHN ST

OLD SHAFT

E INN

SHAKESPEARE INN

HOP POLE

STATION

CROSS HEATH

RAILWAY INN

THE WATERLOO

MALT SHOVEL

NEW INN

LOZZARDS ST

PRICE ST

GREAT WESTERN RAILWAY

GOODS SHED

RED CROSS KNIGHT

OLD HOUSE AT HOME

SADDLE AND STIRRUP'S

CROWN AND ANCHOR

WHEAT SHEAF

BEE HIVE

WELLINGTON INN

BROWN JUG

WHITE ROSE

TEMPLE STREET

BILSTON FOUNDRY

BARREL INN

OLD BROWN JUG

WAGGON AND HORSE'S

STAR INN

JAPANNERS ARMS

ELEPHANT AND CASTLE

MARKET ST

WHITE LION

ROBIN HOOD

BROWN LION

BOATBUILDERS ARMS

BARLEY MOW

SHAMROCK

HOLYHEAD RD

BLUE BOAR

WINCHESTER ST

STAR AND GARTER

ROYAL EXCHANGE

STANLEY STREET

ATLAS BEDSTEAD WORKS

GREAT WESTERN RAILWAY

BOVEREUX FURNACES

INTRODUCTION

A seventh volume of 'Britain in Old Photographs' about our area is quite an achievement and it is *our* area – make no mistake. Bilston and its surroundings belongs to all of us, for it is our own history and that of our parents and theirs before them that has shaped it into what we know today. Throughout the seven volumes, the area is now documented in over 1,600 pictures which record our general, industrial and social past. The old adage says 'every picture tells a story' and stories of the area still flourish.

Things have changed a lot around Bilston. That's no surprise. The brutal iron industries of the past are now distant memories to the older generation, but there will always be historians bringing it back to life by searching out our special 200-year industrial heritage. Likewise the great eighteenth- and nineteenth-century coal rush in the vicinity, which brought both extreme wealth and extreme poverty. Both are well depicted at the Black Country Living Museum, where visitors can get a real insight into this corner of the Black Country in years gone by.

The motor car has given us great freedom compared to former modes of transport – tram, train, bus and walking. Today there is no limit to travel, be it into the local countryside or the far reaches of the globe. But for most, our roots are firmly planted here. In our own individual ways we each cherish our memories of the past we knew.

So we have a past that is well worth remembering and I trust that this seventh book, along with the others, has provided not only a nostalgic read but something that readers can always refer back to while on trips down memory lane.

Ron Davies, 2011

ONE

BILSTON

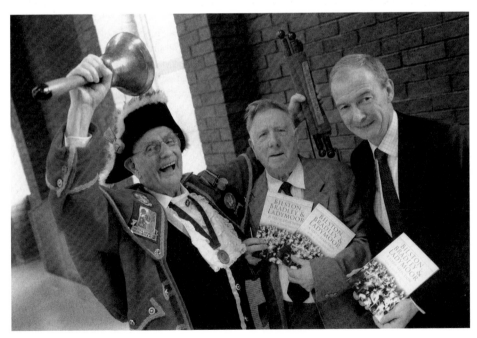

The launch of the sixth book of *Bilston, Bradley & Ladymoor in Old Photographs*, which took place at Bilston Baptist Church on Saturday 5 December 2009, sees the author Ron Davies assisted by town crier Mr Percy Simmonds and supported by local member of parliament the Rt Hon Pat McFadden MP.

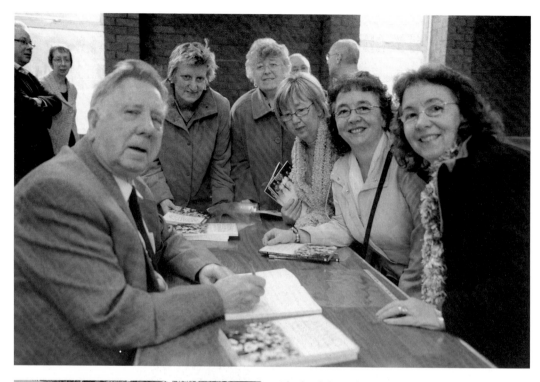

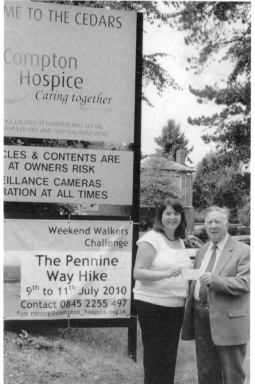

The book launch signing sees the author, then, from left to right in the background, Adrian Pye, Anita Cooper and around the table are Pam Hazlehurst, Iris Woodings, Joanne, Pam and Gillian (née Matthews). Photographs of the day were taken by Graham Beckley, photographer for the Black Country Society.

At the Cedars Compton Hospice, Ron hands over a royalty cheque for £500 to fund raiser Suzanne Davies on 3 August 2010.

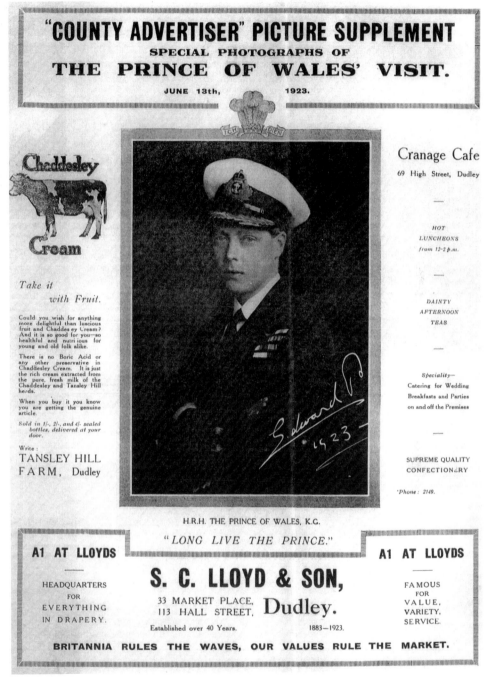

Until this supplement was handed to me to complement this seventh selection, I had no idea that the Prince of Wales (later Duke of Windsor) had ever visited Bilston! He did so on 13 June 1923. His itinerary for the day included Dudley, Wolverhampton, (Royal Hospital) Bilston and Wednesbury, and I am aware he passed through Bradley after opening the Birmingham New Road on 2 November 1927.

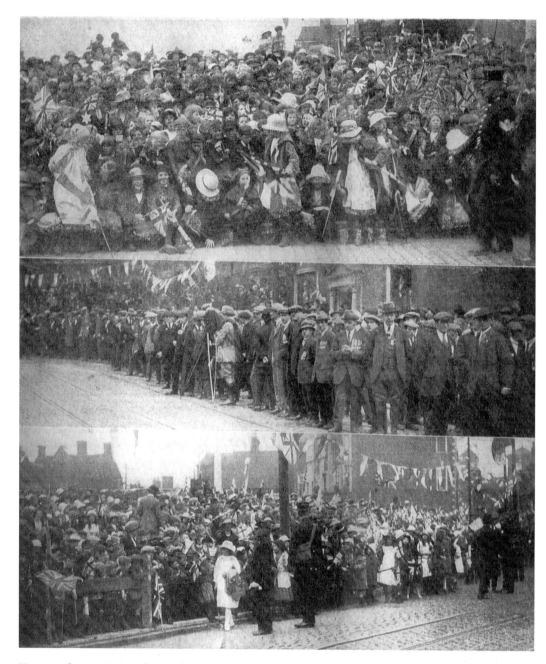

Here are three pictures taken in the vicinity of the War Memorial on the day of the royal visit. The first picture shows the school children, the second shows a parade of ex-servicemen and the third scene shows even more children. This third scene has changed little over the years. Note the rear of Barclay's Bank and to the right we see the tower of St Leonard's Church and the clock tower of the Town Hall. *(Ian Bott)*

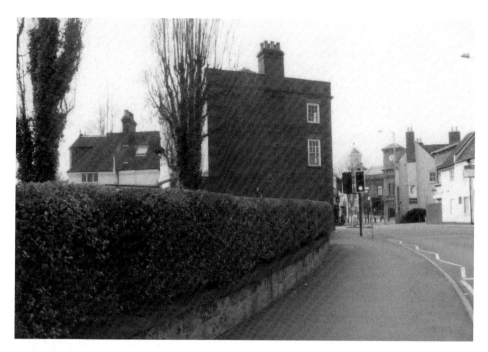

The 1923 scene as it appears today, with Barclay's Bank, the tower of St Leonard's Church and the Town Hall. *(Author)*

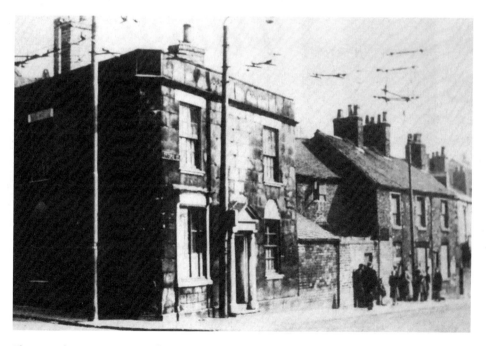

This was the scene opposite the War Memorial where the ex-servicemen stood. The building on the left faced with Bilston stone has long gone, as are the other nearby properties. *(Bilston Archives)*

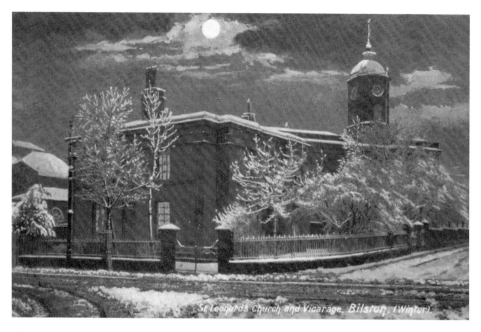

These are two early twentieth century shots by John Price & Sons of Bilston, taken in Bilston during its most picturesque time. St Leonard's Church and its vicarage never looked more scenic . . . *(Ian Bott)*

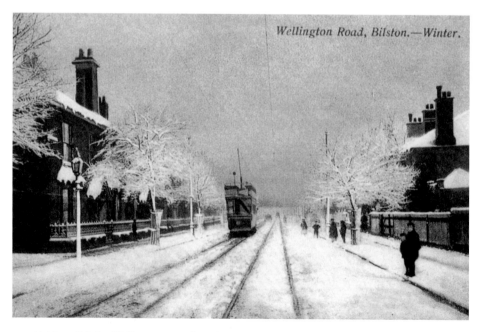

. . . Neither did the Wellington Road with its tram and tram lines – not forgetting the few bystanders who braved the weather for this shot. *(Ian Bott)*

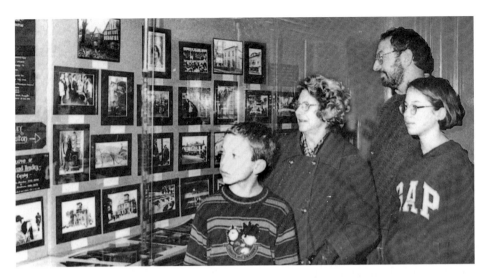

A former Bilston family, Angela Bird, daughter of Thomas Reay Wood of Bilston cinema fame, seen here with her son and two grandchildren viewing a Bilston photographic exhibition at Wolverhampton Central Library, where many photographs concerning Wood's cinema were on show. *(Roy Hawthorne)*

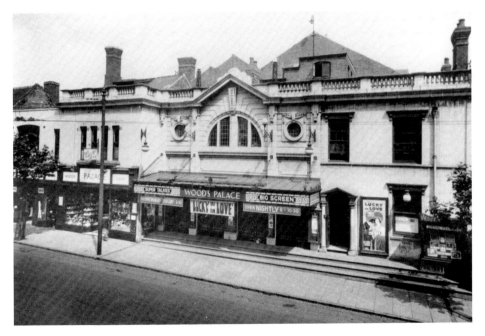

Just to refresh the memory, here is a 1929/30 view of the Wood's cinema or Palace as it was known. It was certainly like walking into a palace with luxury fitted carpets, furnishings and plush velvet seats. Such luxury was almost unheard of for most of the working public at that time. It would have been a far cry from the ubiquitous pegged rugs and scrubbed table tops of most folk, all this and talkies too for 3*d* or 6*d* for a balcony seat! *(Roy Hawthorne)*

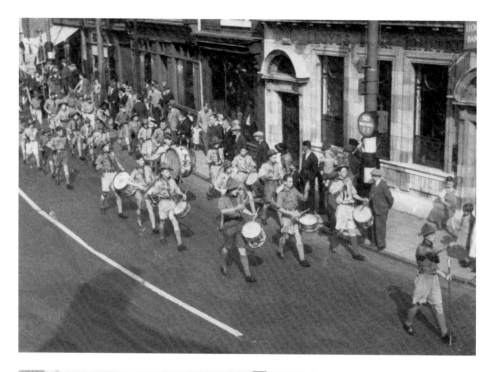

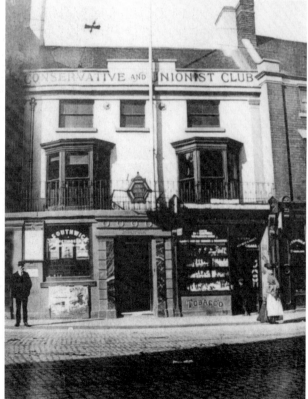

1948/9 saw the 6th Bilston Scout band parading along Lichfield Street. On the mace is Ron Beasley; on the first three rows from left to right are Norman Richards, Derek Price and Roger Baker; second row: D. Kingston, John Clemson and Charlie Southall; third row: Ralph Smith and Tony Baker. Others include Reg Ashley, Brian Webb, Keith Jones, John Carter and Reg Lanyon. *(Brian Webb)*

An early twentieth-century photograph shows the former Conservative and Unionist Club, which stood in Lichfield Street just opposite the Town Hall. They are now long removed into Mount Pleasant. *(Bilston Archives)*

Councillor and Mrs John Willis Pearson pose as Mayor and Mayoress on being elected in 1942. John, a Conservative, served on the council from 1933. In Bradley an Avenue is named after him. *(Willis Pearson family)*

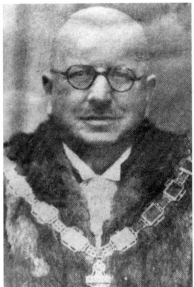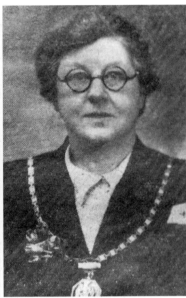

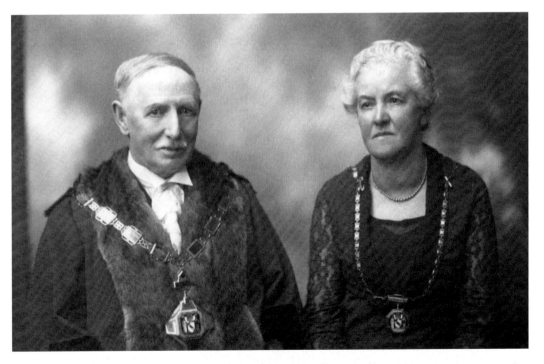

Councillor and Mrs G.A. Plant were unanimously chosen to serve as Mayor and Mayoress from November 1938. He was both an architect and surveyor and served as a Conservative councillor for the New Town ward. *(Willis Pearson family)*

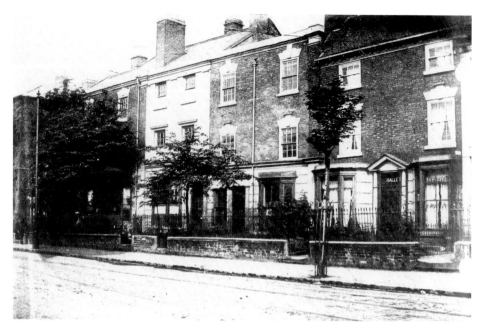

A 1920s view of Mount Pleasant looking from Bow Street. *(June Parkes)*

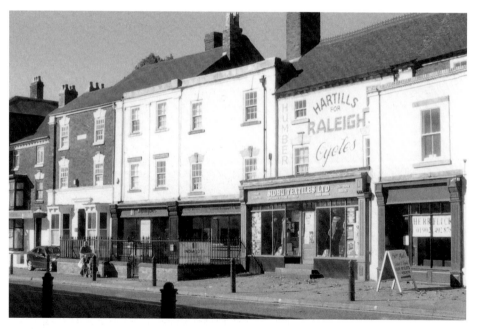

The same today, showing little has changed other than that shops have taken over the former private residences. Harthill's moved on to the site soon after the Second World War. During the 1930s they had a small shop on the opposite side of the road, now demolished, where they earned a living charging batteries (accumulators) for the old-fashioned wireless sets. *(Author)*

This shows a view of the police station in about 1977, seen on the right, and on the left is what was probably 'The Mount'. This was demolished along with its neighbour, the Globe Inn, to make way for a police station car park. *(June Parkes)*

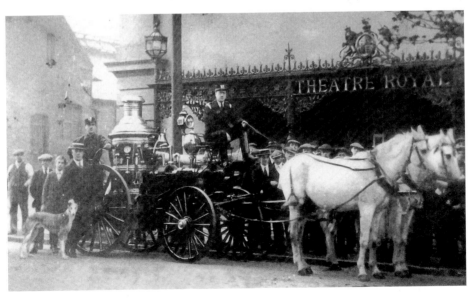

An early 1920s view of the Theatre Royal and what appears to be a very highly polished fire engine. *(June Parkes)*

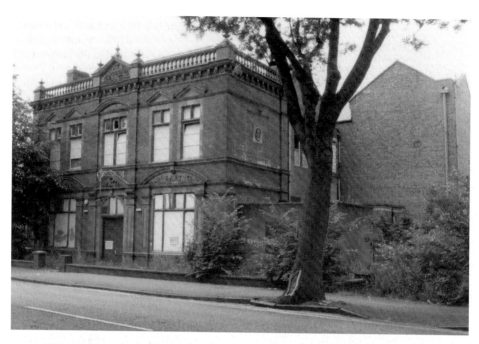

Once the pride of Bilston, the Technical College in this scene now stands forlorn and empty.
A tablet near the door states that it was laid by Mr J.W. Sankey on 28 October 1896. *(Author)*

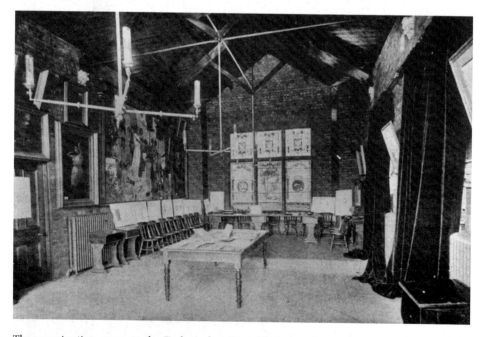

The examination room at the Technical College, Bilston, as it was in 1900. The desks and
chairs surround the spacious room and the sturdy radiators provided wonderful central
heating. *(June Parkes)*

Here is a 1950s view of the former Bilston windmill. The rather dark passageway behind the children included a recess in the windmill wall, as seen below. *(Wolverhampton Public Libraries)*

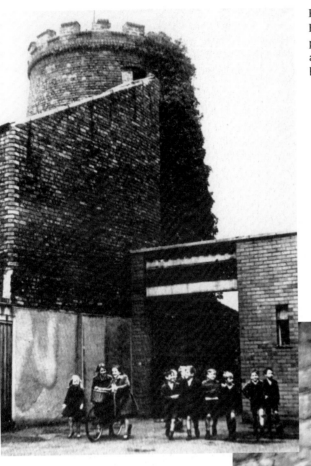

Here the aforementioned recess shows a section of rattle chain, presumably so contained for posterity, but was lost with the demolition of the mill. As coal mining came to an end due to the coal strikes in the 1920s, the Whimsey engines became redundant and the miles of rattle chain that worked the cages up and down the shafts lay about everywhere. Most were put to use as simple fencing, especially around lawns. None to my knowledge now exist in our area. *(Wolverhampton Archives)*

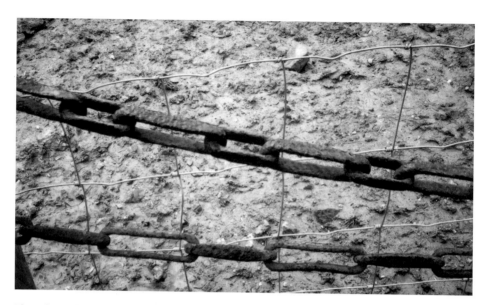

Though rattle chains may no longer exist in our area, a little is to be found around the squatter's cottage at Blists Hill Industrial Museum at Coalbrookdale, as seen here. *(Adrian Pye)*

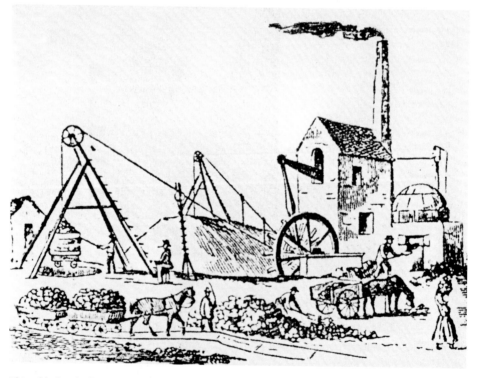

This old sketch shows what a Whimsey engine was. It must have been a very noise place in real life with all the activity and chains rattling to and fro. The chains are seen here stretching from the wheel to the frame standing astride the pit shaft. *(Wednesbury Central Library)*

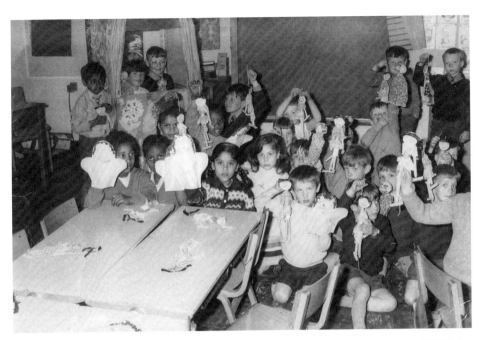

Moving out of Mount Pleasant and almost immediately into the Willenhall Road we find the Green Acres Junior and Infant School. Here we see an irrepressible class of infants, all showing off what was probably their day's work of creating puppets. The girl behind the girl and boy in front is Gail Nichols and the boy to the right behind her covering his mouth with his hand is Alan Parkes. *(June Parkes)*

The two ladies seen in the photograph here donated by June Parkes are (top) her grandmother Fanny Evans and her great-grandmother Harriet Richards.

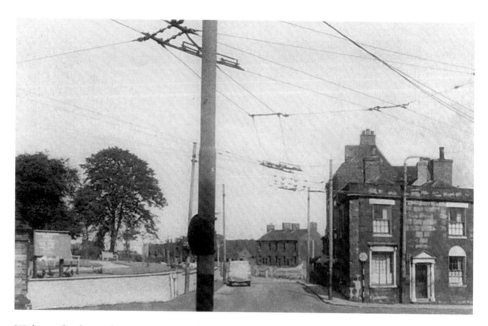

With our backs to the War Memorial in Oxford Street we see this view of Fraser Street from the 1950s. The complex overhead tram-lines, besides carrying on to Darlaston, also served as a stop to reverse certain trams back to Wolverhampton or to the tram depot in Mount Pleasant. *(June Parkes)*

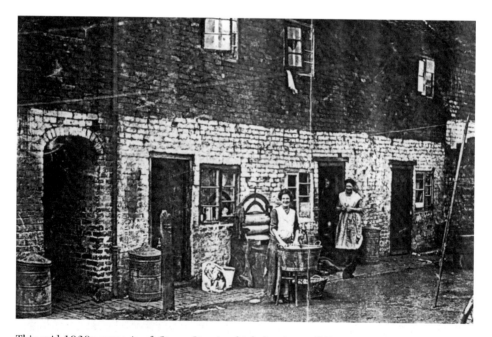

This mid-1930s scene is of Stone Street, which lies just off Fraser Street and behind the previously mentioned former Bilston stone house. One of my early recollections of Stone Street was that one of the ladies here was very good at making treacle toffee and cheap too for a penny! *(Bilston Library Archives)*

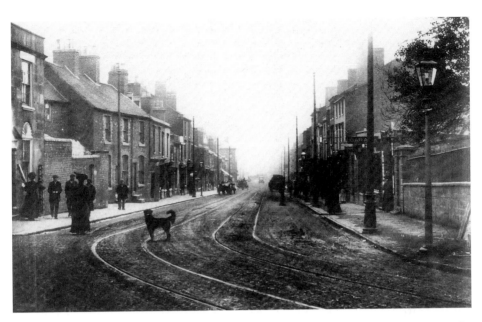

Here we have a splendid early twentieth-century view of upper Oxford Street. Note to the left a little of the 'Bilston stone house' and to the right a 'Bilston stone' wall and wrought iron railings enclosing a small park where later the War Memorial was set. Just to the side of the park wall and a little above, there is a sign for what must have been one of the town's earliest garages. *(June Parkes)*

Not much character here now but more or less the same Oxford Street scene today. We have a lot to thank the old photographers for, also the local archives and *Express & Star* who preserve them for future generations. *(Author)*

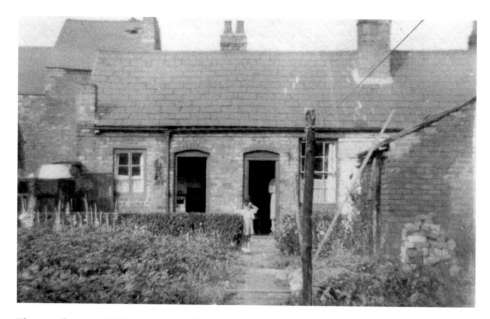

These rather neat little cottages with gardens were known as Bowen's Cottages. They were situated in Duck Lane just off Queen Street. The scene was photographed in 1951.

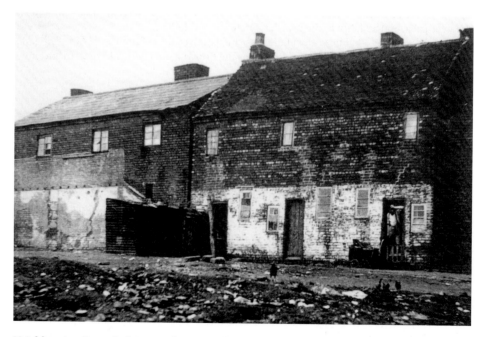

Neighbouring Bowen's Cottages, these nameless properties look the worse for wear. At least the tenants had a bonus of free-range eggs judging by the chickens scratching around. These were the so-called 'good old days', no cars on the drive here, just a lone pram. *(Bilston Library Archives)*

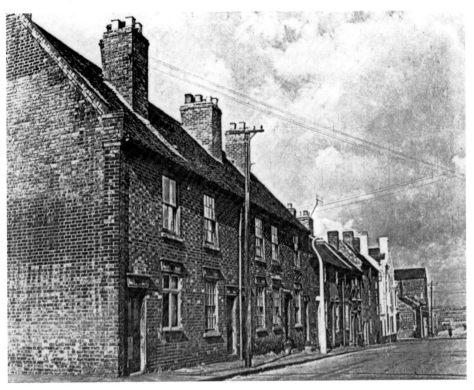

This is a view of Chapel Street looking towards Oxford Street and directly onto Hare Street. The near gable end building formed part of Temple Street. Judging by the television aerial and modern electric street lighting, I would guess this photograph is from the 1960s. The pub, a white building on the far corner was known as the Brown Lion. *(Bilston Library Archives)*

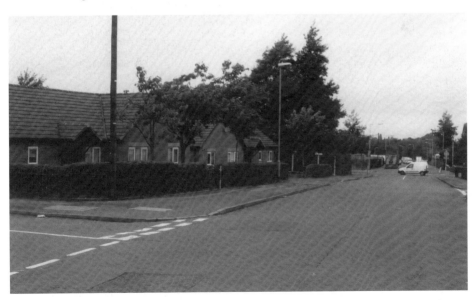

This is the same Chapel Street scene today. *(Author)*

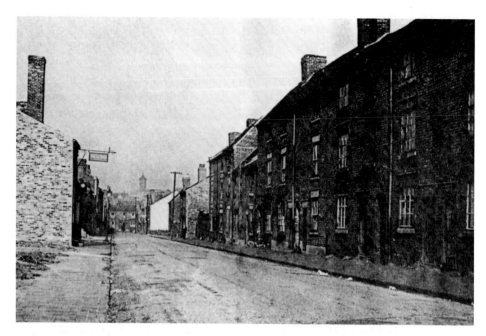

This is a 1960s Temple Street scene looking towards Bilston town centre and showing the tower of St Leonard's Church in the distance. The nearest building on the left with the overhanging sign says 'White Lion'. The houses opposite appear empty, awaiting demolition. *(Bilston Library Archives)*

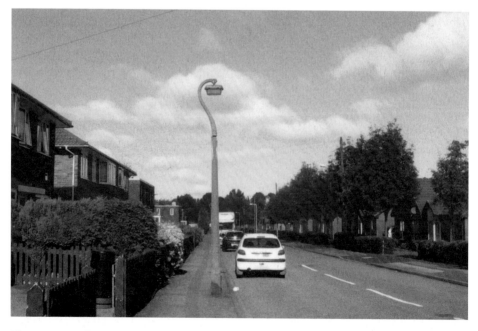

The same Temple Street scene today. The tower of St Leonard's Church, however, is obscured by trees in the distance. *(Author)*

Directly on the acute bend of Chapel Street, here is a contrasting sunshine and shadow scene of Bradley Street. *(Bilston Library Archives)*

Bradley Street today as it winds its way to create a mini rural scene. *(Author)*

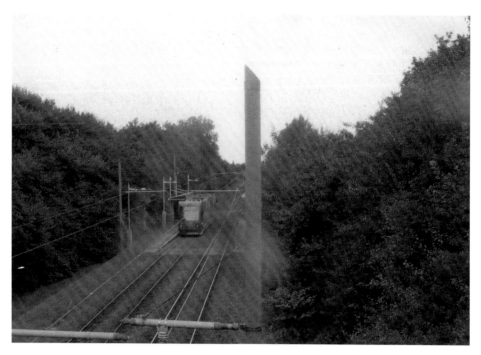

Adjacent to Chapel Street is the ever-popular Metro passenger rail service between Birmingham and Wolverhampton. This scene shows the Loxdale stop. *(Author)*

This shows the same spot but in 2000 when the line was under construction. *(Author)*

Bilston Brook appears from its source on the slopes of Hurst Hill, Sedgley. The brook, until it reaches its utmost Bilston–Darlaston boundary, is completely ducted. In these last few watery yards in Bilston, the builders of the huge properties seen on the left, to improve the site, also landscaped around the area of the brook. *(Author)*

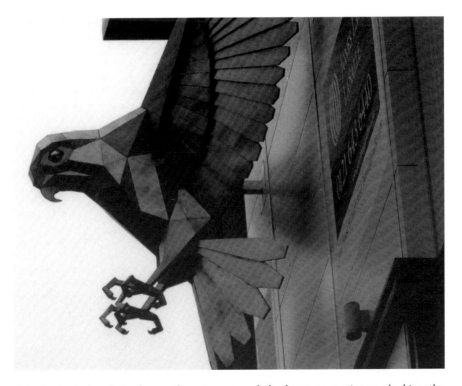

A last-minute touch to the north-east corner of the huge properties overlooking the brook, this eye-catching eagle-like sculpture also dominates the junction of the Black Country Route and the Black Country New Road. *(Author)*

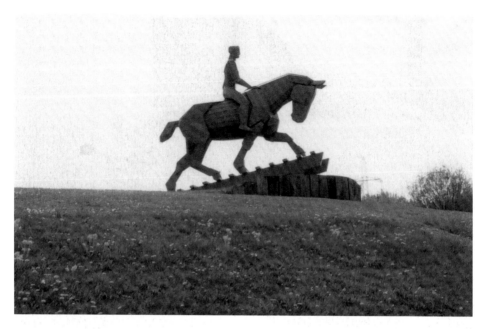

Other sculptures also dominate this motorway junction. This equestrian effigy dominates the southbound route, while in spring the cowslips take over. *(Author)*

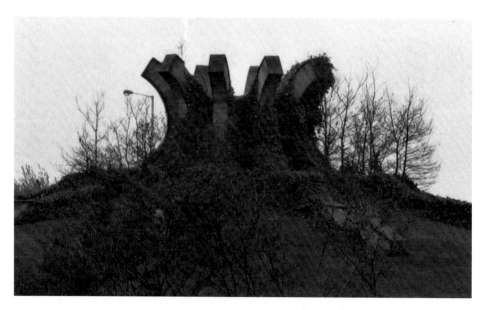

On the mound of the Lunt traffic island here, stands this unusual sculpture, looking like a crown roast! It was originally created to hold an oak tree but the tree quickly withered away. Oak trees are a rarity in our Black Country. *(Author)*

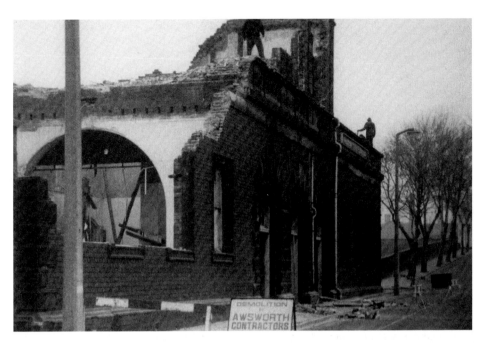

This 1971 view, a little nearer to the town, shows the demolition of the Bilston railway station. Note the signage of the demolition company. *(Ian Bott)*

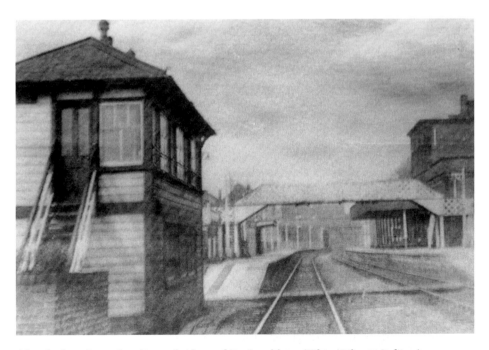

A last look at the station, its overbridge and its signal-box. *(Bilston Library Archives)*

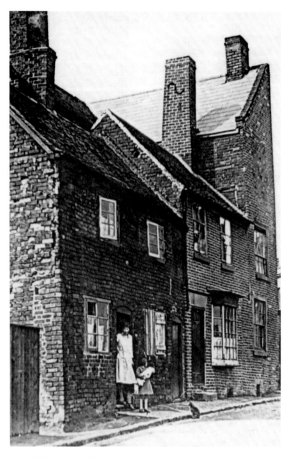

Close by the railway station was once located the area of Pipes Meadow, so named after the Pipe family who supposedly lived close by in Hall Street in what once was Pipe Hall. The present Pipe Hall is a rare three-gabled property, though now finely façaded, but I wonder about its future? The 1950s scene here is one of pure tranquillity with a mother and her daughter – is she nursing a baby or a doll? – not forgetting the pussy cat. It is difficult to imagine its former rural setting of fresh meadows rolling away into the distance during the pre-industrial Pipe era. *(Bilston Library Archives)*

The earlier mentioned Hall Street runs from Swan Bank to the Pipe Hall or the Metro railway bridge, there joining up with Market Street from which point this photograph was taken in about 1950. The street seen on the left is Bath Street, where once stood St Mary's Vicarage (the birthplace of Sir Henry Newbolt) and opposite the vicarage once could be found the Bilston morgue. The building on the far corner of Bath Street was Bilston baths. On the opposite side of the road, the first building housed Hawkins's bicycle shop, then came Stafford Street and beyond the large building came Wood Street. *(June Parkes)*

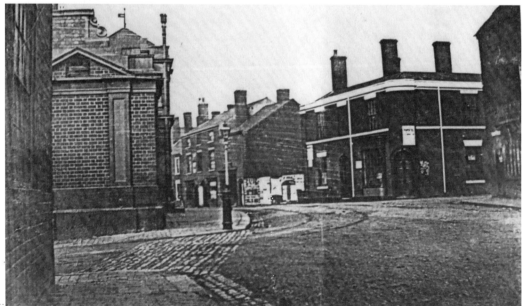

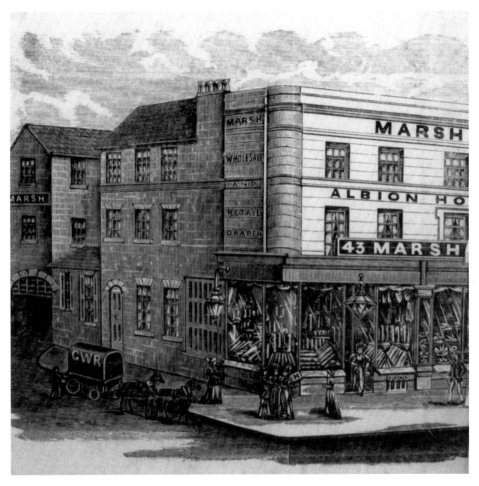

Venturing into the town in 1900, we come across the noted Marsh's Wholesale and Retail Drapery Store in Church Street. A greengrocery and bank now occupies the site. *(Jen Hayward)*

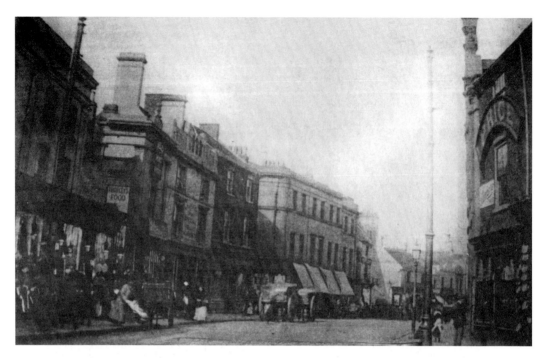

This is more or less a general view of Marsh's store, seen here with the awnings. The scene from the early 1920s also notes the shops, etc. From left to right are Snape's drapery, Shelley's chemist, Market Tavern and the Lion. St Leonard's Church tower can just be made out at the end of the white building. Notice Price the printers shop just on the right of the picture. *(John Price & Sons)*

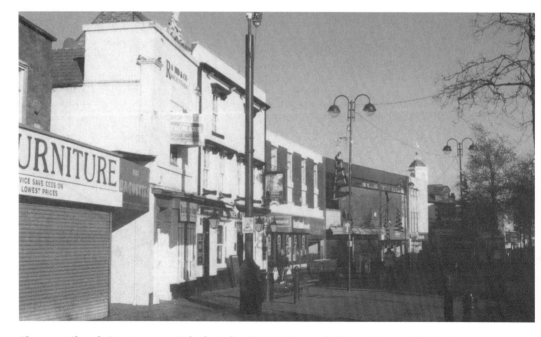

The same Church Street scene as it looks today. Note St Leonard's Church tower. *(Author)*

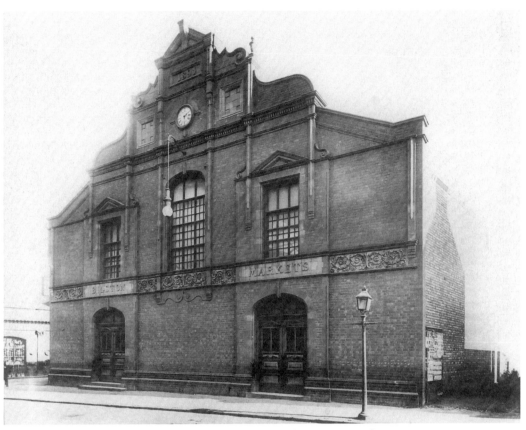

Above: Here we see the old Bilston Market with its splendid Arts and Crafts façade. Note the single electric light hanging from just below the clock, also Delaney's Ironmongers to the left of the scene. It was demolished in the early 1930s to make way for a Woolworths store, now also gone.

Here are two 1970s views of the outdoor market. No car restrictions at that time. *(John Piper)*

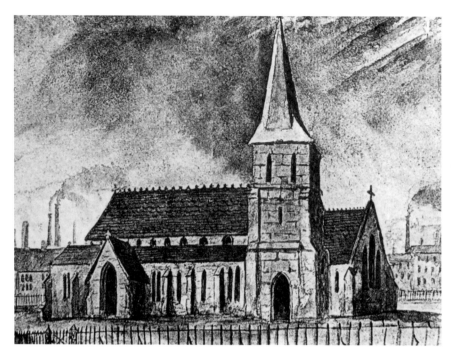

Here is an early sketch of St Luke's Church as it was in Market Street. Its spire was removed in about 1939 and the church itself in 1975. Its primary school stood just to the west of the church.

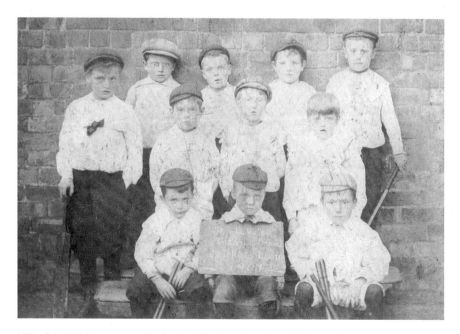

This delightful scene speaks for itself. The placard held by the boys says 'St Luke's Infant School Cricket Team – 1907'.

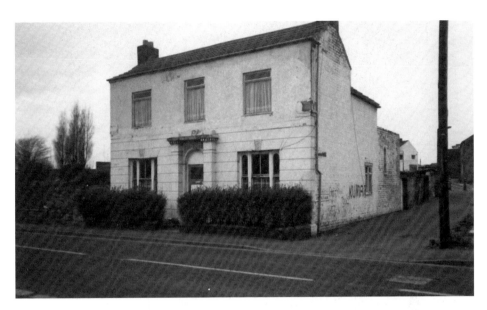

Leading on from Market Street entering into Prosser Street (so named after the Revd William Prosser, a long-serving vicar of St Luke's astride the nineteenth and twentieth centuries). One of the last buildings to remain here was Stonefield House, as seen here in 1980. The street seen at the side of the house was Stonefield Walk. *(Ian Bott)*

When the old houses in Stonefield Walk were demolished, Beach's Furnishers took over the site but retained the front lower half of the houses to form a wall for privacy, simply bricking in where the doors, windows and entries were. It remained like this for many years but today the whole has been plastered over, ah well! Note the Greyhound and Punchbowl pub to the left of the scene. *(Author)*

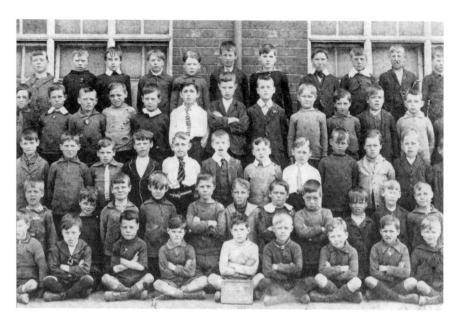

Still in the Stonefield area comes this old Stonefield school photograph. The simple placard seen on the front row simply states 'Standard Three Class 1922'. The only boy known here is John Leslie Unitt (known as Leslie) seen in the middle of the second row down with arms folded. There were no school uniforms back then. *(Peter Unitt)*

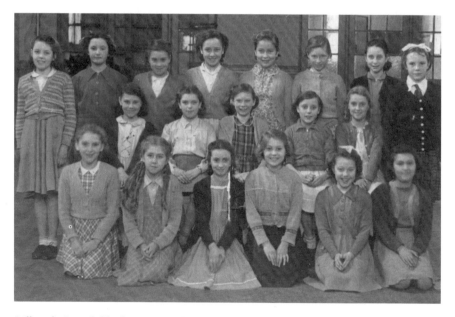

Still with Stonefield, this time with the girls Junior School Country Dancing Team of 1954. Back row, left to right: Linda Lavender, Nova Bentley, Pat Davies, -?-, Thelma Williams, Janice Nicholls, -?-, -?-. Middle row: -?-, -?-, -?-, -?-, Sandra Bromley. Front row: Carol Sheldon, -?-, Carol Robinson, Brenda Cartwright, -?-, Margaret Dickins. *(Linda Webb, née Lavender)*

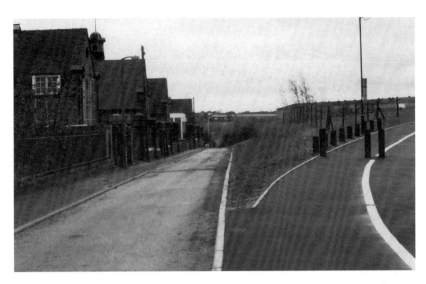

Seen here is the west view of what was once Stonefield boys' school, now long disused. The road seen fronting the school meanders down to a path leading to the Capponfield and Highfield area. The path seen going off to the right partly follows an old railway track that once existed between Coseley Road station and Prosser Street. A large buffer or stop stood on the margins of Prosser Street at least until the early 1940s. *(Author)*

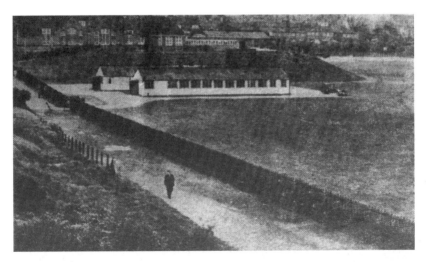

The previously mentioned road fronting the school is seen here looking back towards the school. The shot was taken from the railway bridge that once existed here. At the foot of the embankment there was once a small allotment garden that produced a phenomenon known as wild-fire or underground fire, due to a smouldering coal seam. The area was known for its unique stench and heat-loving crickets. The general picture shows the school sports field and the school in the background. The immediate sports field was once the site of Stonefield blast furnace. The general view today is in the grip of some busy educational development. *(Express & Star)*

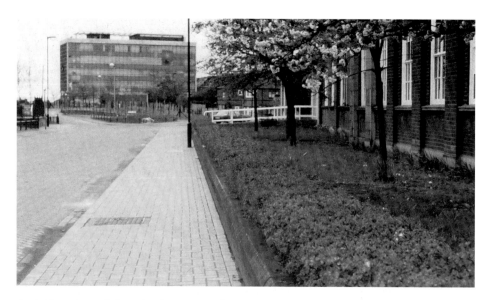

A parting view of the school at its north aspect. It is at present in use under the title of Wolverhampton South and Bilston Academy. Directly on in this view from about 1994 we see the tiny Linton Croft housing estate with the former Sankey's offices in the background. That site is now occupied by a new sports centre and swimming baths. Most of the scene here shows what remains of Prosser Street. It was never a busy traffic route, until the new Black Country route was completed, most if not all traffic passed through the town. *(Author)*

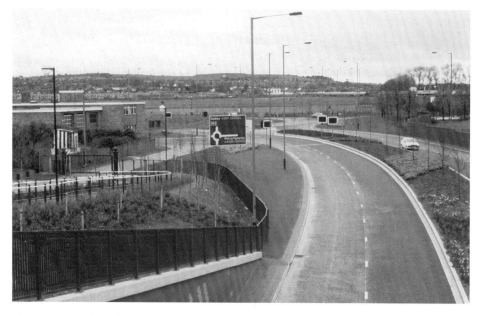

The motorway, though completed, was still quiet traffic-wise. As seen here in this photograph from about 1994, motorists still preferred the old straightforward town route. In this scene we see on the left Charlie Purslow's pigeon loft with the new fire station behind, covering the site of the former Union Inn in Coseley Road. *(Author)*

Mentioning the Union Inn in Coseley Road, here are two of its early licencees: Mr Alfred and Mrs Sarah Parrish in about 1880. (Iris Woodings)

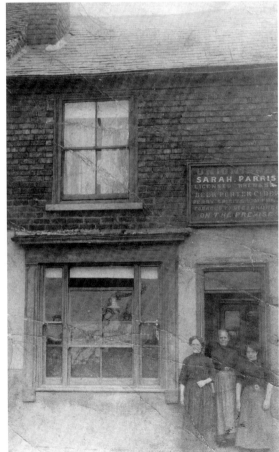

This photograph of the Union Inn in about 1895 shows that Sarah Parrish was the licensee, though by 1900 her husband Alfred had taken over. Had Sarah by then perhaps passed away? Posing in the doorway from right to left are Gertrude Foster, aged sixteen, Keturah Wedge, sister of Sarah Parrish and Sarah Wedge, daughter of Keturah. Gertrude married one Thomas Edward Cox of Ladymoor and they were paternal grandparents of Iris Woodings who supplied the photograph. The inn was demolished in about 1988.

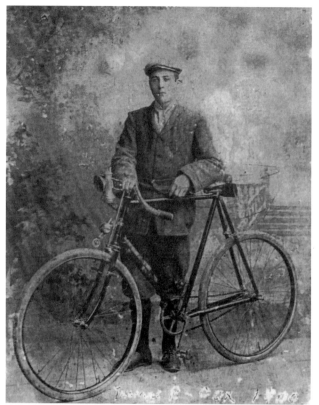

This 1900 photograph shows Thomas Edward Cox doing a studio pose beside an early bicycle. On marrying Gertrude Foster they lived in Coseley Road and were to have five children, namely Alfred, William (Bill) father of Iris Woodings, Sarah, Thomas and Cyril. Thomas Snr died aged thirty-seven in the great influenza epidemic of 1918. *(Iris Woodings)*

This early 1932 wedding photograph of Ada Wilkinson and William (Bill) Cox sees, standing from left to right, Cyril Cox, Edith Wilkinson, Nell Nicholls, bride Ada Wilkinson, groom William Cox, Thomas Cox and Constance, wife to be of Alfred Cox who is standing next to her. Sitting from left to right are Samuel Wilkinson, Winifed Wilkinson, Sarah Cox and Gertrude Cox (Foster). The Wilkinsons were a Deepfields family who we shall meet with again. *(Iris Woodings)*

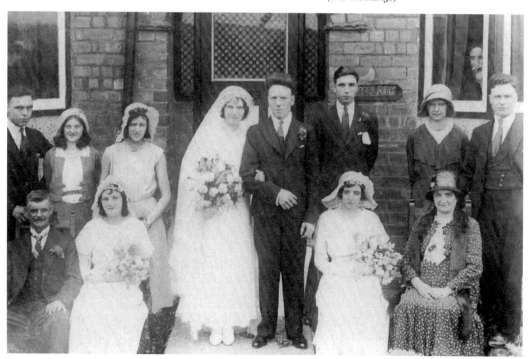

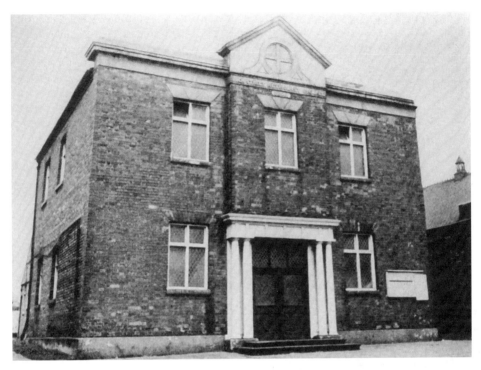

This is a view of the former High Street Methodist Church. The last services were held here in 1962. *(Peter Unitt)*

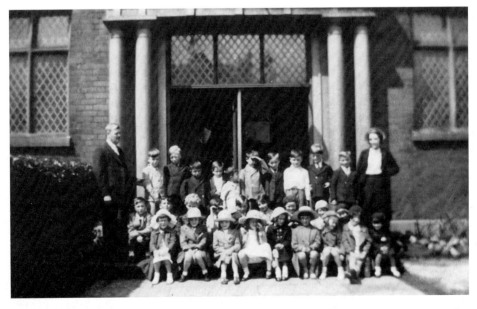

Posing here are mainly the children attending the High Street Methodist Junior Sunday School during the 1920s. The only identifiable person here is Mr John (Jack) William Unitt on the left of the picture. *(Peter Unitt)*

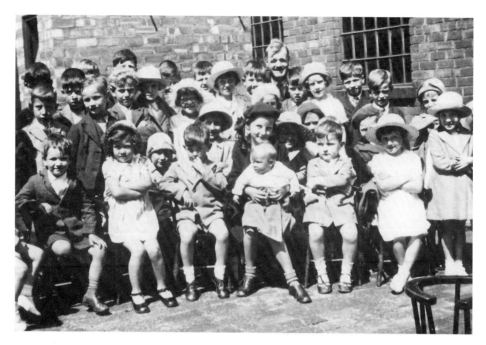

Another Junior Sunday School scene from the 1920s. This time Jack Unitt is seen at the back of the group. *(Peter Unitt)*

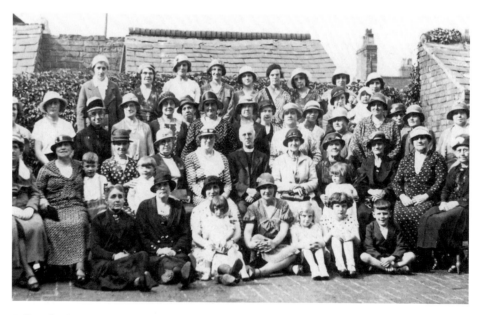

Still with the Methodist Church, again from the 1920s. This shows a women's meeting group. Peter Unitt, who supplied the photograph, notes that his two grandmothers are to be seen in the group. First is Jane Ellen Unitt – sitting on the floor, fourth adult from the left and in front of the minister – and Sarah Gertrude Faulkner who is sitting next to the minister on his right. *(Peter Unitt)*

What is probably the last remaining foundry in Bilston is Formcast Ltd of Shale Street, which more or less also corners Wolverhampton Street. They specialise in high-quality alloy castings, being established here at least since the 1870s under the name of Branford Brothers. The building seen here, though now much tidied up, is probably the oldest industrial building remaining in town. A steel beam or truss here shows the date 1876. *(Author)*

Another view of the said foundry building. The former cupola furnace stood to the right of the scene where the raw materials were melted to be run into various moulds to form useful castings. Now new and cleaner methods are used to melt the special metals needed. *(Author)*

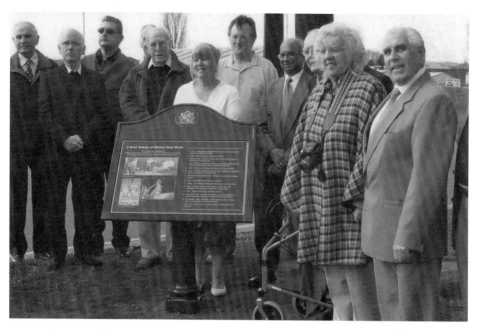

The plaque seen here was installed on the crossroads of High Street, Millfields Road, Wolverhampton Street and Coseley Road and unveiled on 12 April 2009 by Lord Bilston for the Bilston Community Association. It was to commemorate the thirtieth anniversary of the closure of the Bilston steelworks. A few people worth noting here are, from right to left, Lord Bilston, Andree Hickney, -?- and Mr B.D. Patel. (*Author*)

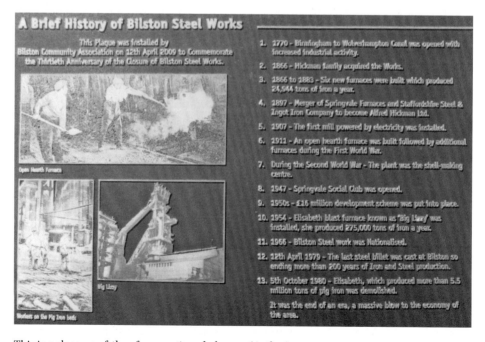

A Brief History of Bilston Steel Works

This Plaque was installed by Bilston Community Association on 12th April 2009 to Commemorate the Thirtieth Anniversary of the Closure of Bilston Steel Works.

1. 1770 – Birmingham to Wolverhampton Canal was opened with increased industrial activity.
2. 1866 – Hickman family acquired the Works.
3. 1866 to 1883 – Six new furnaces were built which produced 24,944 tons of iron a year.
4. 1897 – Merger of Springvale Furnaces and Staffordshire Steel & Ingot Iron Company to become Alfred Hickman Ltd.
5. 1907 – The first mill powered by electricity was installed.
6. 1911 – An open hearth furnace was built followed by additional furnaces during the First World War.
7. During the Second World War – The plant was the shell-making centre.
8. 1947 – Springvale Social Club was opened.
9. 1950s – £16 million development scheme was put into place.
10. 1954 – Elisabeth blast furnace known as 'Big Lizzy' was installed, she produced 275,000 tons of iron a year.
11. 1966 – Bilston Steel work was Nationalised.
12. 12th April 1979 – The last steel billet was cast at Bilston so ending more than 200 years of Iron and Steel production.
13. 5th October 1980 – Elisabeth, which produced more than 5.5 million tons of pig iron was demolished.

 It was the end of an era, a massive blow to the economy of the area.

This is a close-up of the aforementioned plaque. (*Author*)

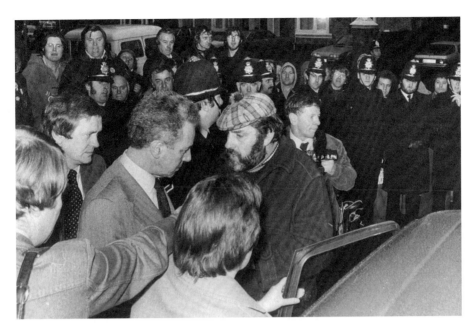

Still with the steelworks, after their existence for 200 years no one in Bilston could believe their time was up. Lads from the works fought hard to keep it going. In this picture from about 1980 we see Bert Turner confronting the then Minister for Works Keith Joseph during a visit to Birmingham. On the right side of the van we see Bill Griffiths and by the policeman on the left is Albert Fellows. *(Bert Turner)*

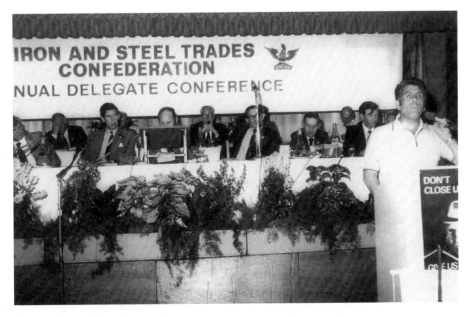

In this photograph we see Dennis Turner at the microphone with Prince Charles looking intently on. Mr Bill Sirs of the steelworks is seen on the left of the prince. The conference took place at Bournemouth in about 1980. *(Bert Turner)*

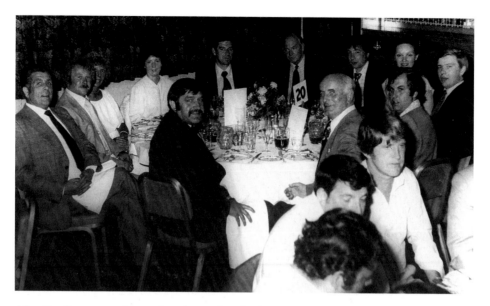

After the Bournemouth meeting the steelworks faithful retired for some refreshment. From left to right we see Dennis Turner, Ron Showell and wife, possibly Mrs Robinson, Frank Robinson and Graham Fazey. In front next to Dennis is Bert Turner who is sitting next to Reg Turley. For all the travelling and confrontations, the end for the works was inevitable. *(Bert Turner)*

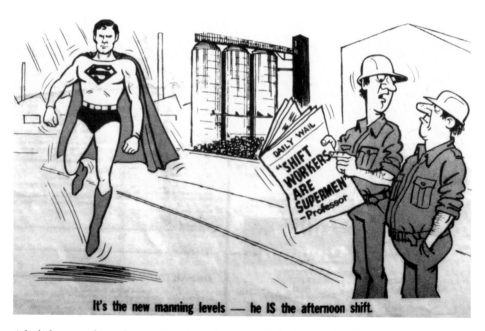

A little humour for a change. A cartoon from one of the last steelworks magazines. However, in truth, for most workers shift work meant 6–2, 2–10 or 10–6 and moved around every week, some men were even happy to do double shifts if someone fell ill, all for a beer ticket. Supermen indeed! *(Steelworks News)*

Here, some of the steelworks office girls pose gracefully for the camera on the works sports field in April 1949. From the left are Iris Cox, Doreen Speed and Iris Jones. *(Iris Woodings)*

Another shot on the sports field, also in April 1949. Left to right: -?-, Doreen Speed, Donald Bell, Iris Cox, Ron Fellowes and Iris Jones. *(Iris Woodings)*

This time the posing takes place outside the steelworks offices in 1951. Seen from left to right: -?-, Pat Hickman, Iris Cox and Frances Ashley. *(Iris Woodings)*

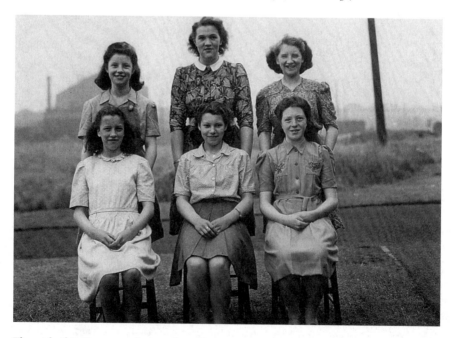

The girls this time pose facing the offices on 10 June 1947. Back row, left to right: Diane Morris, Audrey Armstrong and Dorothy Pearle. Front row: Beryl Leddington, Jean Porter and Iris Cox. Note E.N. Wright's construction shop in the background. *(Iris Woodings)*

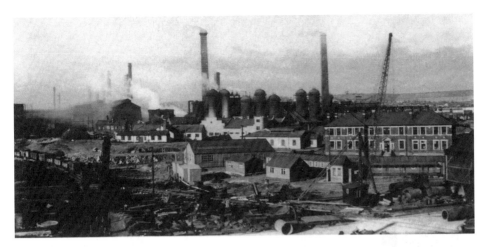

This scene was shot from the top of E.N. Wright's construction shop. It shows an overall view of the steelworks, pre-Elisabeth furnace days. The buildings on the extreme left of the scene housed the mill and the large gable-ended building housed the Siemens steel making open hearth furnaces. In the centre background were the blast furnaces – probably three were working in the 1940s. Most noticeable are the domed hot blast or Cowper stoves. The white building in front of all this housed the works canteen and swimming baths and on the right of this are the works offices. In front, but well away from the offices, is the jib-crane, belonging to the E.N. Wright's tank department, created in about 1941 to do war work. A little of this building can be seen on the extreme right of the picture. *(John Piper)*

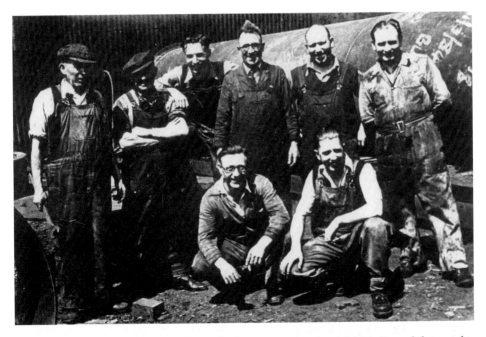

These are some of the men of the tank department in about 1950. From left to right, standing: Ted Cooper, Harry ?, Harold Jones, Jack (Sandy) Powell, Selwyn Jones and Albert Piper. At the front: Ted Locket Jnr and Ron Davies. *(John Piper)*

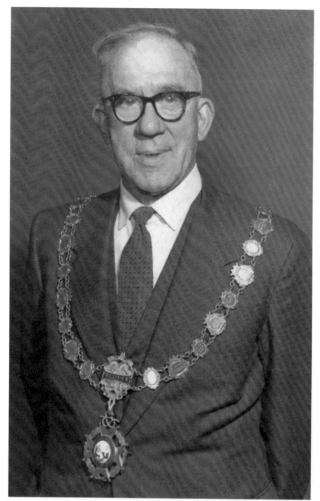

This is Mr Alfred Bunce. He worked for E.N. Wright at the steelworks as an erector of blast furnaces and general construction work. He was believed to be president of a death and dividend club, hence the chain of office. *(Fred Bunce)*

Here is a treasured steelworks photograph from about 1910, showing a group of laboratory assistants momentarily pausing from their chores, in what was then Alfred Hickman's before being taken over by Stewart's and Lloyds in 1920. Unfortunately only one person is known, that is Edward (Ted) Southan, seen on the extreme right. *(John (Jack) Southan)*

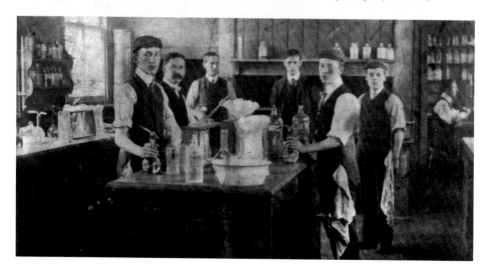

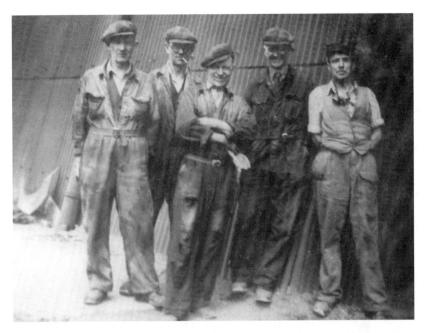

These lads, too, from the scrap baling plant take a break from their labours to do a little pose for the camera. They are, from left to right: -?-, Fred Bunce Snr, -?-, Bill Amos and -?-. *(Fred Bunce Snr)*

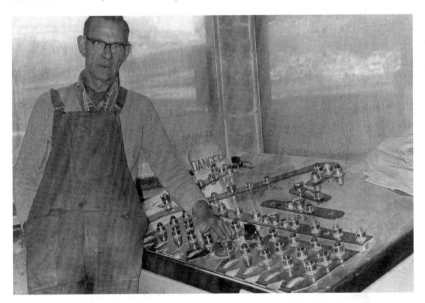

Here we see Fred Bunce Snr at the control panel of the material handling plant in the year he retired (1968) after serving 51 years in total. He first worked in the rolling mill, mainly fetching beer from a local pub nicknamed 'The Cot' for the ever-thirsty rollers. He earned a ½d for every pint, which averaged 30–40 pints a day, a nice little earner that would all but double his official weekly wage of about 6s per week in 1916–17. *(Fred Bunce Snr)*

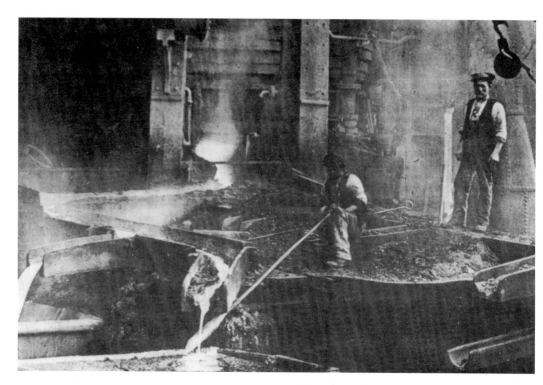

An early 1920s furnace scene showing a slagger making a slag ball for use in controlling the flow of iron after tapping the furnace. The conditions here appear very primitive but these men at the time were worth their weight in gold, yet it was just a job! The man in the background is thought to be the keeper or foreman responsible for the management of this lower part of the furnace and for tapping it. The turned-up brim of his old trilby was thought to carry away the rain on a wet day, but more likely to quickly let other men know who he was. *(Steelworks News)*

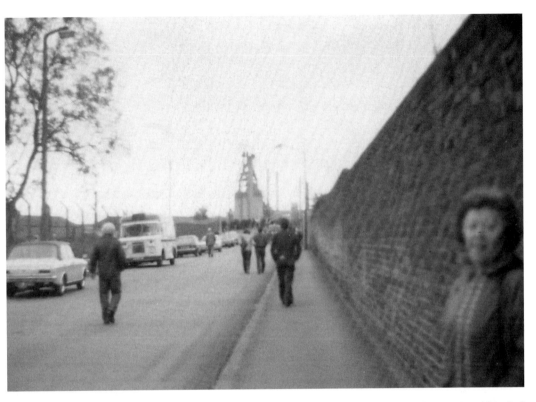

On the day the Big Lizzy was felled, 11 a.m. Sunday 5 October 1980, all roads in the area were blocked off due to the anticipated explosions. It was a big disappointment for many who wanted to record this sad moment. Strangely the media were allowed into the prime positions! The nearest I could get was Ward Street, Priestfield, and unbelievably the batteries in my camera failed, hence the poor quality of this shot before completely jamming up. *(Author)*

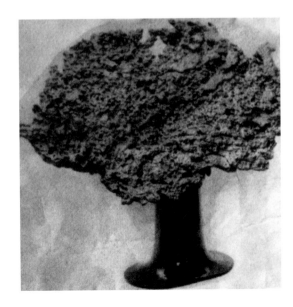

Seen here is a chunk of bear iron or salamander from Elisabeth's final cast. Bear iron is the accumulation of metal, which gathers below the tap-hole during the working life of a blast furnace. Some bears can weigh up to 250 tonnes but this piece of 40lb was rescued by Sid Beasley, who was in charge of the blast furnace materials and acquired by manager Barry Hodgson who fashioned it into an oak tree and offered it to the Bilston Museum and Art Gallery, where it still remains on show albeit minus its trunk-like mounting. Although it may look 3D, it is actually rather flat. *(Steelworks News)*

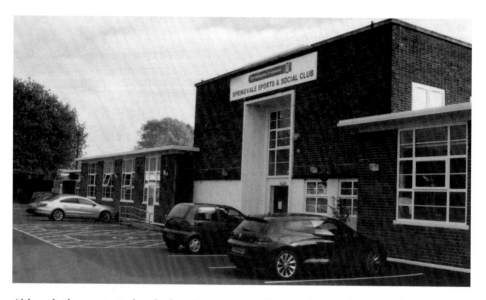

Although the great steelworks has long gone, its Springvale Social Centre, dating back to 1940–1, is still in evidence and long used by its former employees but now open to members of the public. *(Author)*

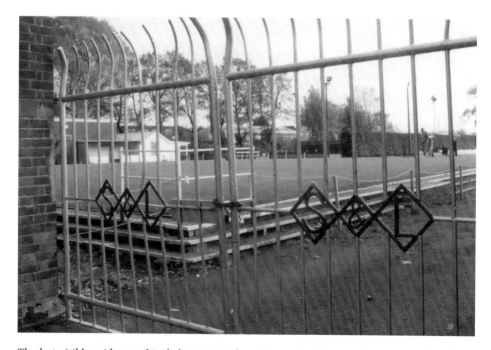

The last visible evidence of its belonging to the great works is seen in the gates at the side of the building, where we see S & L motifs. Also in existence is the bowling green, which is still in use, as are the sports fields. Up until 1940 the site was occupied by a lone cot that was the home of the Moore family, Jim Moore being the works policeman. At that time the land thereabouts was littered with scrapped Bilston stone grind-stones. *(Author)*

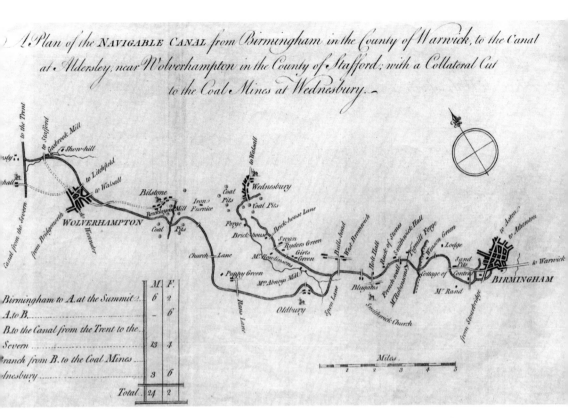

A simple but effective map from the *Gentleman's Magazine*, October 1771, showing the Birmingham Canal Navigation's canal system to Wolverhampton as it was in its earliest days. *(Ian Bott)*

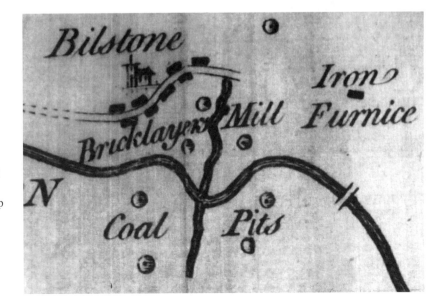

This is an enlarged section of Bilston taken from the map above. This part shows the church, John Wilkinson's Furnace and the Bricklayers' Mill. *(Ian Bott)*

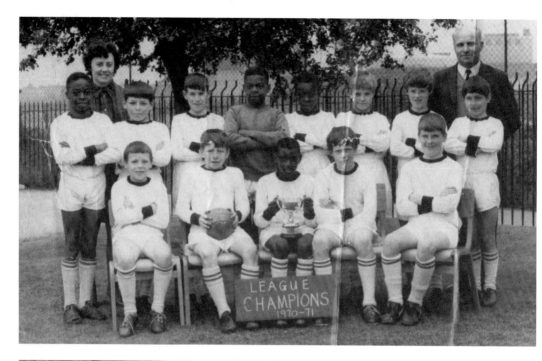

This rare picture is from the Ettingshall–Priestfield area of Bilston. It shows a group of young footballers from the Ettingshall Primary Junior School football league cup winning team of 1970–1. It shows two teachers, the man being Mr Jones. On the back row, from left to right, are: Morris Linton, -?-, Anthony Mason, Victor Linton, Delroy Douglas, David Bennett, -?- and -?-. Front row: -?-, David Pearson, Leroy Douglas, Reginald Priest and Russell Gordon. The cup was presented by Wolves player Mike O'Grady. *(Brenda Mason)*

There really is very little information concerning this particular Newcomen engine set up to work in Bilston, but it was said to pre-date the engine built for the Earl of Dudley in 1712. However, there are certain papers acquired by the Wolverhampton Archives by a person named Short confirming this. Short appeared to be an accountant and caretaker of the said engine to the local mine owners and as noted on the reverse of this postcard, the said engine was sited in the Hall Park Street area of Priestfield before being removed to Dudley in 1916. *(The Black Country Society and Ian Bott)*

The great Thompson's works, like the steelworks, has now gone. This is one small feature that stood at its eastern end and was residence for one of the Thompson staff. It was built by one Kenneth Hutchinson Smith, a Canadian and brother-in-law to John Thompson. Smith also built many fine Tudor-style properties around the Wolverhampton district. *(Author)*

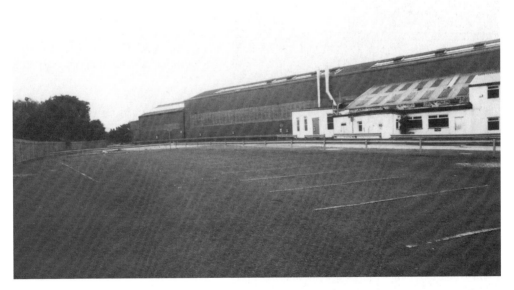

This and the following two pictures show the extent of this once-great works. *(Author)*

These next pictures show whatever Thompson's made, they did so with real seriousness. These huge hydraulic presses prove it. *(John Thompson's brochures)*

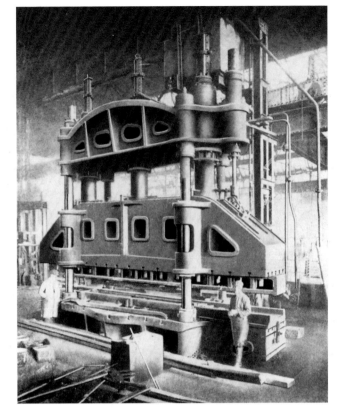

Whatever is going on here? Well, it's a group of men working on the Sunbeam motor chassis. The 1,000hp car set up a world speed record of 203.7928mph on 29 March 1927, driven by Henry Segrave at Daytona Beach, Florida.
(John Thompson's brochures)

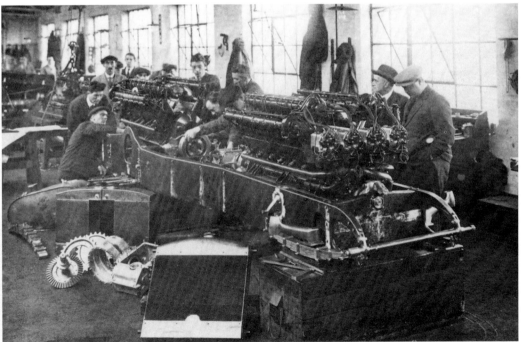

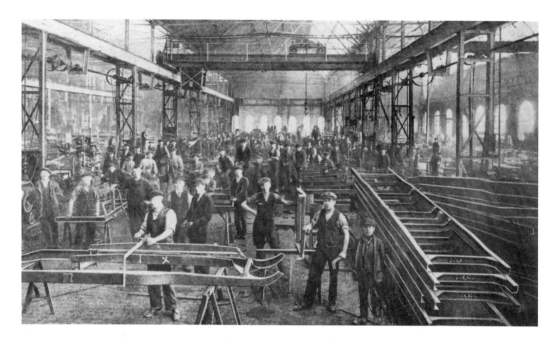

This is a view of the chassis frame erecting department (Motor Pressings), 1927. It would appear that Thompson's found employment for most of Bilston and surrounding district. *(John Thompson's brochures)*

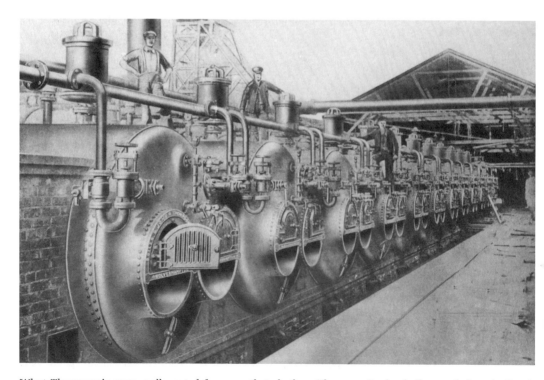

What Thompson's were really noted for were their boilers. These particular boilers ended up in South Africa to work in the mines there. *(John Thompson's brochures)*

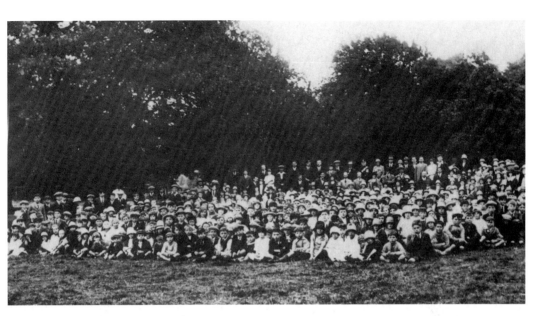

The Thompson's employees may well have earned a pittance but they were appreciated with luncheons, excursions, parties, etc. This scene shows employees children enjoying an outdoor summer party. *(John Thompson's brochures)*

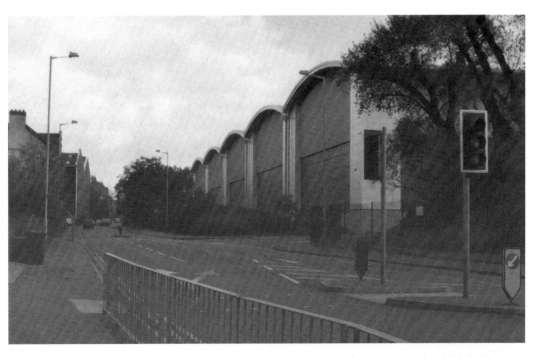

Modern business units now grace the former Thompson's south site. They are very much like the ones noted earlier on the east fringes of Bilston, but no-one in these recession-hit days is really interested in occupying them! *(Author)*

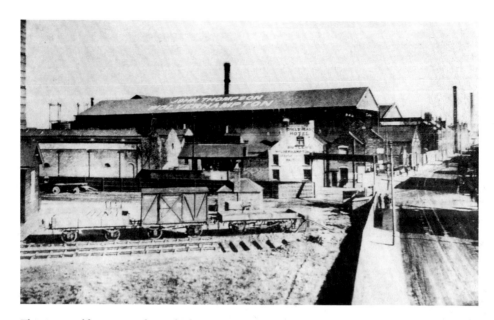

This is an old picture taken of Thompson's north factories from the railway bridge. Note the roof of the first building – it clearly states JOHN THOMPSON WOLVERHAMPTON. Passengers on the trains going past could hardly miss it. Note the Bull's Head Hotel in front of the factory, now a complete ruin. To the immediate left was once the LMS Ettingshall station and goods yard. *(Author's Collection)*

More or less the same view today but taken from ground level, the railway bridge now being inaccessible. *(Author)*

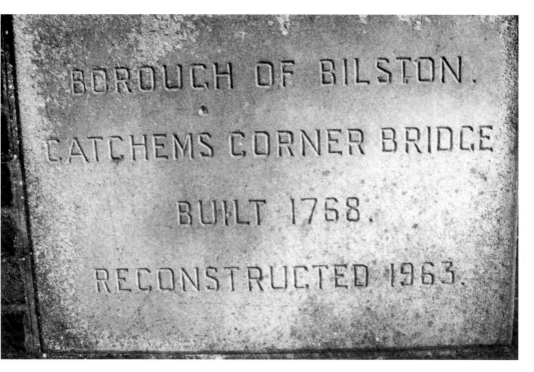

The previous picture was sited at a crossroads of Millfields Road, Parkfields Road, Manor Springs Road and Ettingshall Road. There once stood here a toll bridge known as Catchems Corner. This picture was taken just along Ettingshall Road and over the canal bridge we notice this plaque. *(Author)*

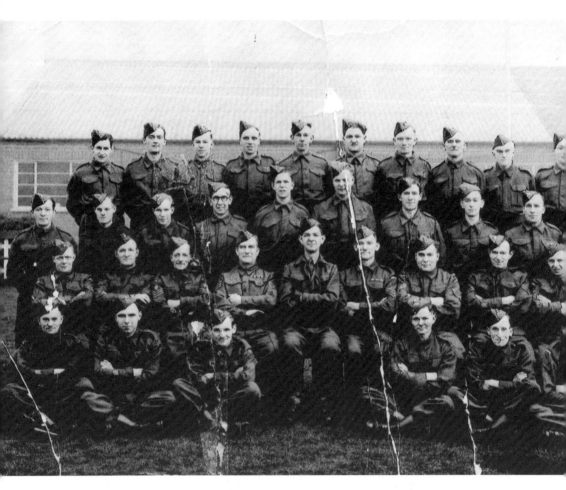

During the early days of the Second World War, Sankey's works, Bankfield, Bradley, as well as Sankey's Bath Street and Albert Street Works, Bilston, were large enough to muster their own Home Guard Companies. After seventy years it is now difficult to put names to many of them posing here, but no doubt many readers will have memories of most of them. However, noted here on the second row down, fifth from left is Jack Perkins. On the bottom row, seated, from left to right: -?-, -?-, Samuel Brown, Thomas Simkins, David Henry Dudley and -?-. *(Ken Brown)*

TWO

BRADLEY

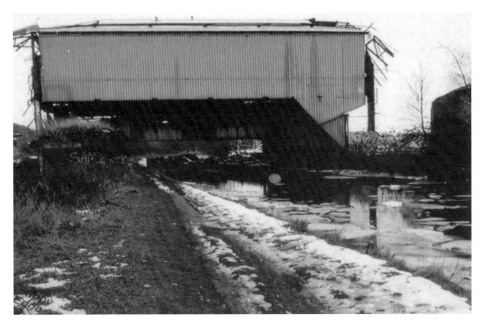

Still on the Sankey's theme, here is the canal overbridge that once carried warmth from a heating or boiler plant on the opposite side of the canal to the works, so keeping the main works reasonably comfortable during the winter months. In this scene from February 2009, the end structures have been removed in preparation for the main demolition.
(Arthur Edge)

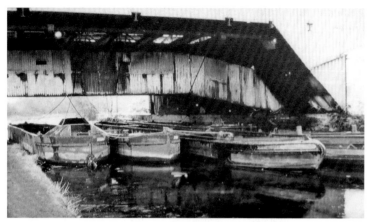

In preparation for the demolition of the overbridge, canal boats were placed underneath and across the canal, so that any stray parts of the bridge would fall into the boats and not into the canal. The photograph dates from February 2009.
(Arthur Edge)

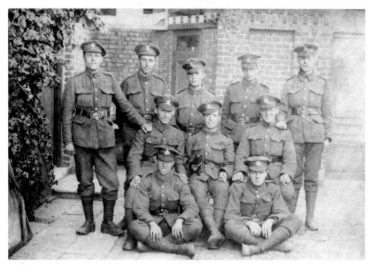

Among the lads posing here at Passchendaele near Ypres, Belgium, in 1917, is Harold Hammonds of 46 Field Street, Bradley, seen first left in middle row. Briefly between July and November 1917, Passchendaele was a costly and unsuccessful offensive against the Germans with nearly 400,000 British casualties including Harold here. His name is on the Bradley Memorial.
(John M. Hammonds)

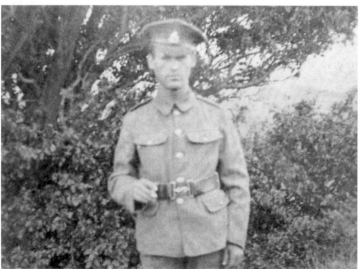

This is a single study of Harold Hammonds, still in Passchendaele, 1917.
(John M. Hammonds)

This is the family that Harold left behind, seen in about 1903. His mother Fanny Hammonds, Harold on the left, Lilly at the back, young Fanny at the front. The children on Fanny's knee are separate surviving twins, the youngest being Trevor, John Hammonds' father.
(John M. Hammonds)

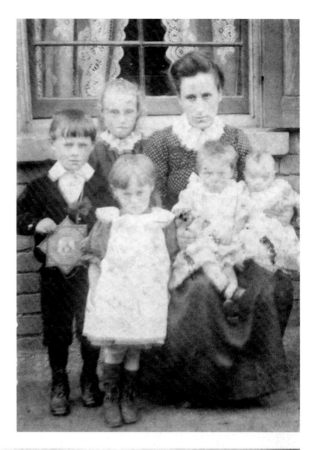

This is an old view of Field Street, looking very patriotic here, celebrating the Armistice on 11 November 1918.
(John M. Hammonds)

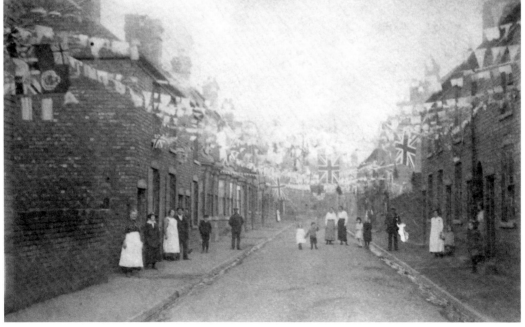

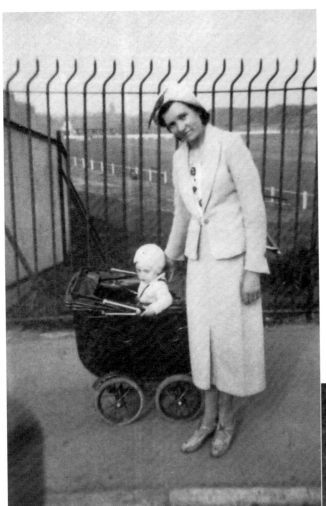

Here we see Mrs Gladys Hammonds of 30 Wright Street (a street off Field Street), wife of Trevor Hammonds, with son John in the pram in 1936. The view today is Dudley Street, looking across Greenway's Playing Field.
(John M. Hammonds)

Here Mrs Gladys Hammonds and son John, in their own way, are celebrating the coronation of King George VI in 1937.
(John M. Hammonds)

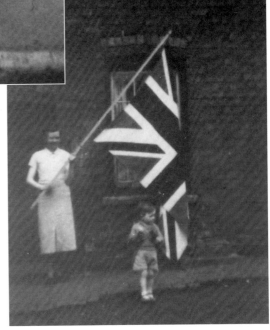

Here comes the bride – local girl Alma
Simkins with her father Thomas Simkins
arriving at St Martin's on her big day,
2 October 1954. *(Alma Boden)*

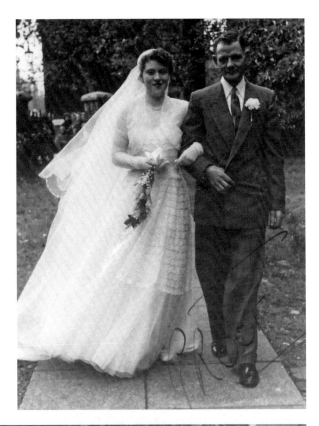

Well and truly wed we now see Mr and Mrs
Des and Alma Boden. *(Alma Boden)*

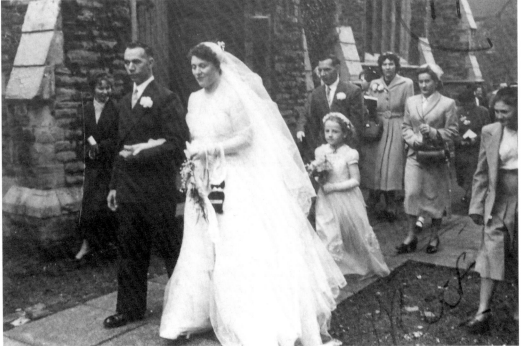

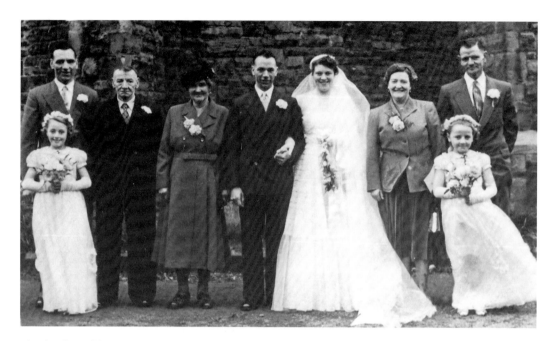

The family wedding group from left to right are the groom's brother Les, father Jabez, mother Hannah, Des and Alma, the bride's mother Lucy and father Thomas. The bridesmaid on the left is Janet Smith, while the bridesmaid on the right is Gillian Kidson. *(Alma Boden)*

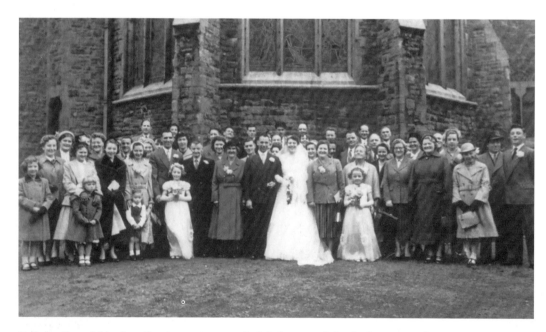

Both family and friends gather to create a wonderful photograph for the happy couple. *(Alma Boden)*

We all love a wedding and this one is no
exception as local newlyweds Mr Harold and Mrs
Pauline Humphries (née Fellows) pose for the
camera outside St Martin's Church on
9 September 1961. *(Pauline Humphries)*

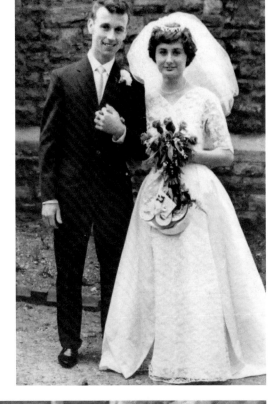

Here Harold and Pauline stand at the centre of
this family shot. The groom's family on the left
are, from left to right, Harold Humphries Snr, best
man Kenneth Paddock and bridesmaids Denise
Richards and Margaret Downs. The bride's family
on the right are bridesmaids Christine Rock,
Rita Humphries and Jack and Mary Richards.
(Pauline Humphries)

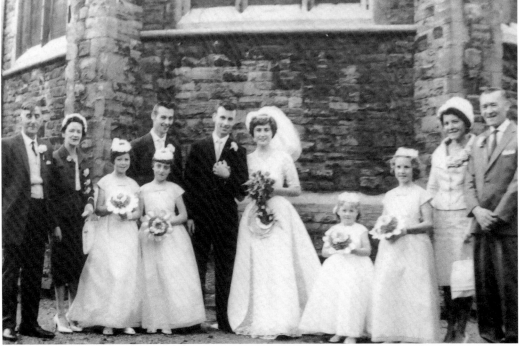

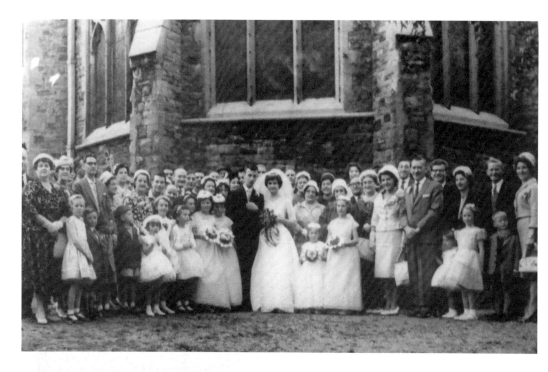

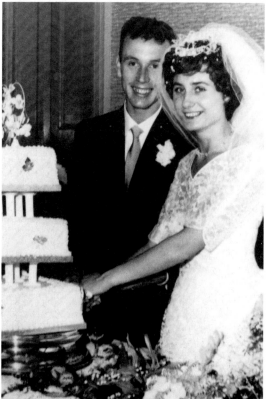

All happily smiling, on the front row up to the groom are, from left to right, Ben Rock, Mrs Holllinshead, Martha Pearson, George Rock, Alice Hazlehurst and Ben Rock Snr. From right to left up to the bride are Betty and Bill Rock, Floss and Dave Webb, Jack and Mary Richards and Violet Bennett. *(Pauline Humphries)*

The wedding reception was held at Clark's café Lichfield Street, Bilston. Here the newlyweds cut the cake. *(Pauline Humphries)*

Though serving the Bradley community for little more than four or five years from about 1954 to about 1958, the Revd Edwin Dentith, seen here, proved to be one of the most popular of St Martin's vicars and was sorely missed when a new living in Jersey was offered. Seen here in this photograph, he was invited to open the 1967 Gala on Greenway Park. *(Alan Webb)*

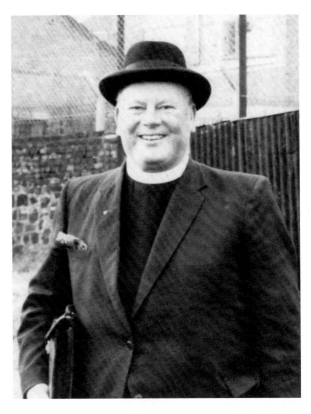

The old 1st Bradley St Martin's scout band (disbanded 1961) reformed for a one-off occasion to head the parade to escort their old vicar the Revd Dentith on to the Greenway Park. Seen here are mace bearer Alan Richards, then from the front going back are, from left to right, John Grinsell, Derek Lavender and Alan Webb; Joe Davies, Alan Davies, and Robert Cooper; Tony Bradock, Geoff Vaughan and Martin Sands; John Lockley, Lou Bradbury and Dave Lavender; Derek Wood, Charlie Edwards and Bryn Jones. In the background we see the Sankey Bankfield offices. *(Alan Webb)*

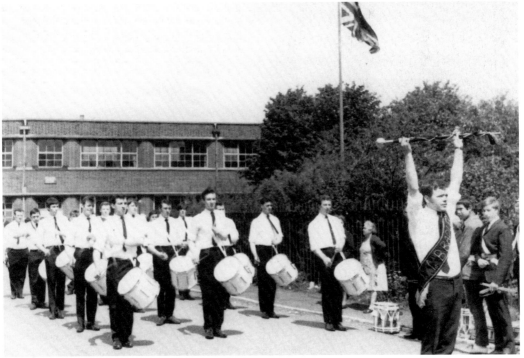

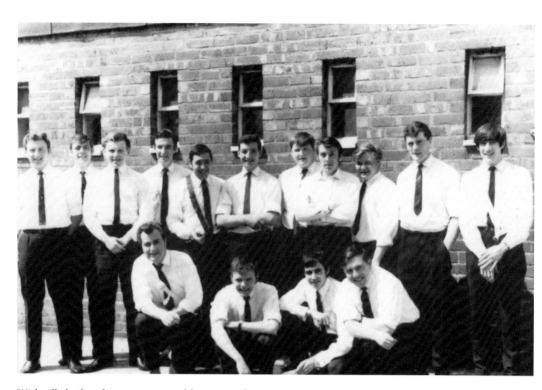

With all the band instruments safely returned to St Martin's School, the band lads pause for this shot. Standing, from left to right, are Alan Webb, Joe Davies, Lou Bradbury, Derek Lavender, John Lockley, John Grinsell, Geoff Vaughan, Alan Davies, Charlie Edwards, Robert Cooper and Dave Lavender. Front row: Martin Sands, Alan Richards, Tony Bradock and Bryn Jones – missing is Derek Wood. *(Alan Webb)*

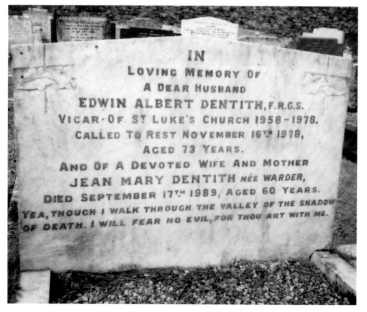

Numerous Bradley folk have visited Jersey in the past to contact the Revd Dentith and probably still do to search out his last resting place here in St Saviour's Church graveyard. *(Alan Webb)*

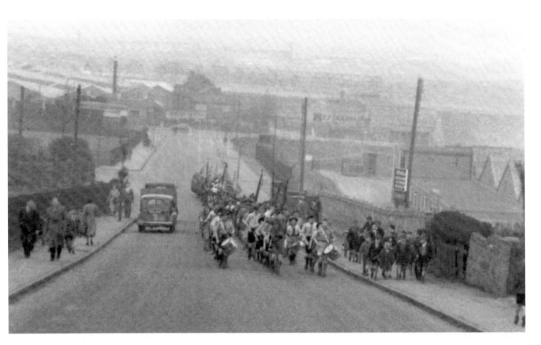

The year – 1954, the occasion – St George's Day 23 April. Here we see the 6th Bilston Scouts coming up Loxdale Street on their way to St Martin's Church. They would appear to have plenty of followers and for 1954 plenty of traffic too! *(Brian Webb)*

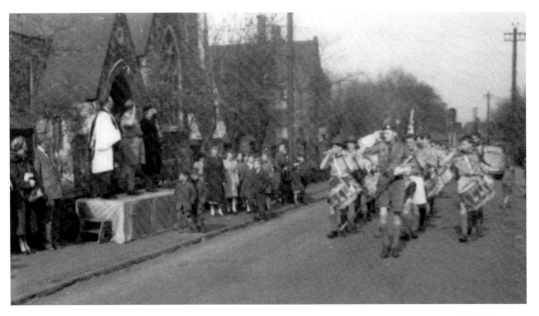

The parade enters into Bradley, coming up King Street. On the mace is Brian Webb. In the band, from left to right, are Donald Williams, Danny Barratt, Bernard Guest and in the middle, Ron Barnsley. On the platform taking the salute are the Revd Dentith and in the centre, Ronald Sankey. Ronald Sankey was a Scout leader and often invited the Scouts to his home in Springhill Lane, Lower Penn. *(Brian Webb)*

Until the clearance of the old properties in Bradley in about 1966–7, Lottie Worrall, seen here on 9 January 1937, was one of the well-remembered characters of the village. The family for many years kept a shop that was situated on the south-west corner of Bank Street and King Street (a photograph of the shop is on page 64 of the first volume of *Bilston, Bradley & Ladymoor in Old Photographs*). The shop sold mainly groceries and paraffin or lamp oil. Many of the old properties until then were still relying on oil lamps for light. *(Kathleen Skowron)*

A nice little group of Bradley girls are seen volunteering a baby minding service. They are seen posing here in the Walter Road area looking across to the old slag heap on the far right and long before the Wilkinson School was built here. From left to right: Betty Garrington, Kath Williamson, Margaret Walker and Irene Williamson. The unseen baby in the pram is Sharon Davison. *(Kathleen Skowron)*

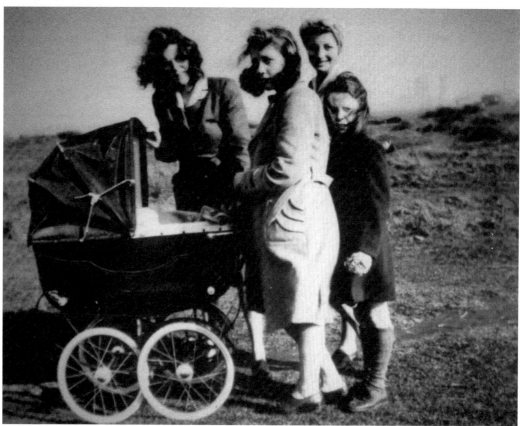

Now in Wilkinson Avenue we see the no. 24 bus trundling along with the shadowy form of St Martin's Church in the background, 1948. The young tree seen to the left of the bus has just been felled (March 2011), yet its remaining stump looks quite healthy. *(Rick Reynolds)*

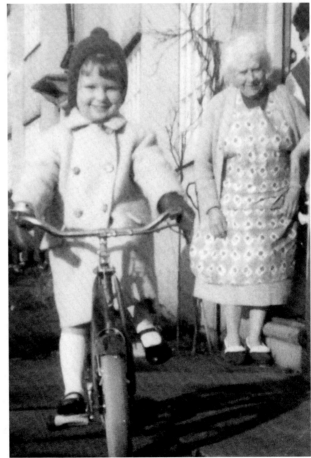

Here little Helen Beards happily shows off her Christmas present bicycle with her nan, Mrs Beards, looking on. What a lovely Christmas day that was. *(Ruth Beards)*

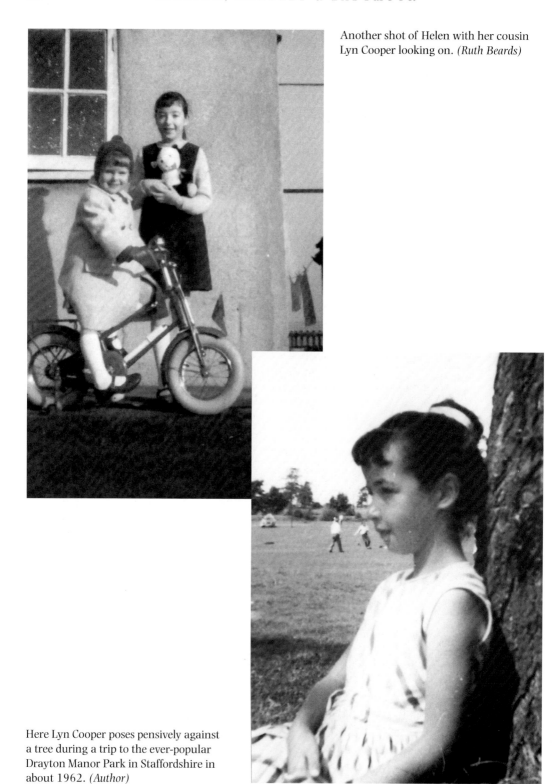

Another shot of Helen with her cousin Lyn Cooper looking on. *(Ruth Beards)*

Here Lyn Cooper poses pensively against a tree during a trip to the ever-popular Drayton Manor Park in Staffordshire in about 1962. *(Author)*

Here's a lovely group of Wilkinson Avenue residents photographed during the 1960s. From left to right are Barbara Taylor, twins Jimmy and Phillip Clayton, Jean Perks, Julie Clayton, Lizzy Perks and Joe Perks. *(Joe Perks)*

Joe Perks and a few Bradley locals enjoy a glass in the now long-gone Bird in Hand Pub in Hill Street. Seen here from left to right are -?-, -?-, Joe Perks, -?- and Mr and Mrs Bert Chapman. *(Joe Perks)*

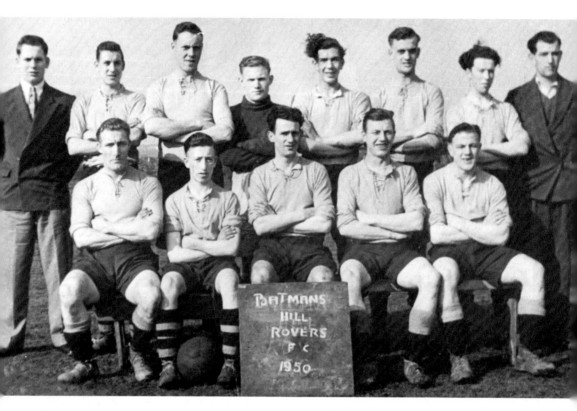

There appears to have been no shortage of football enthusiasts about Bradley in earlier days. Unfortunately only one can be named here and that is Joe Perks, seen on the back row, fifth from the left. As we can see from the placard, these footballers belonged to the Batman's Hill Rovers FC in 1950. *(Joe Perks)*

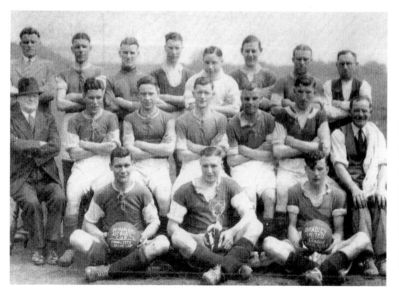

As I said, Bradley folk really enjoyed their football. This time we see the Bradley United league champions with the coveted Astbury Cup in 1938/9. Again only one player can definitely be identified and that is William Pope who is second from the right in the middle row. *(Joe Perks)*

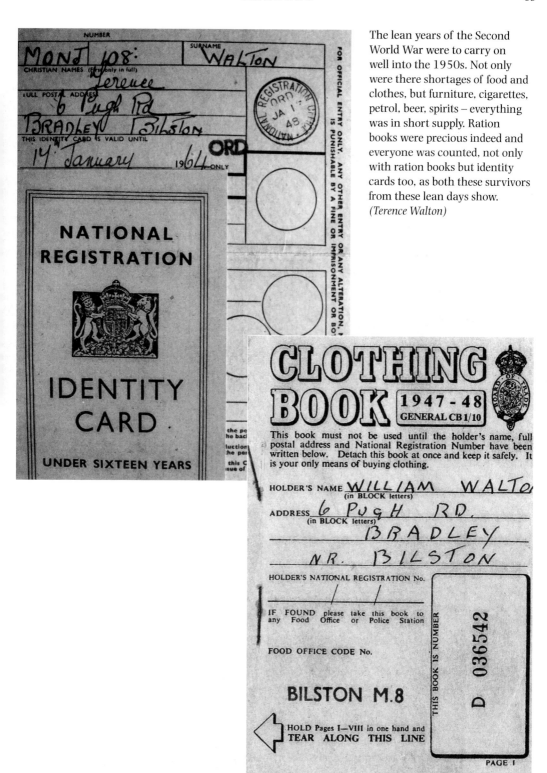

The lean years of the Second World War were to carry on well into the 1950s. Not only were there shortages of food and clothes, but furniture, cigarettes, petrol, beer, spirits – everything was in short supply. Ration books were precious indeed and everyone was counted, not only with ration books but identity cards too, as both these survivors from these lean days show.
(Terence Walton)

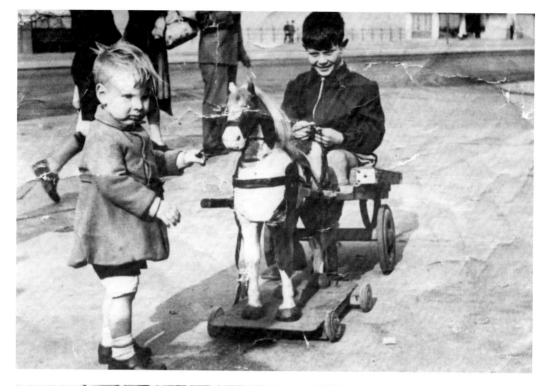

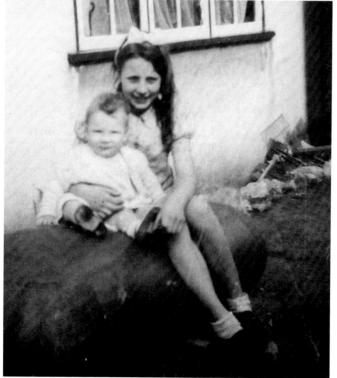

These pictures identify the people connected with the previously mentioned ration book and identity card. They are Terence Walton and, on the simple horse contraption, William Walton. This scene is at Blackpool in 1951. *(Terence Walton)*

Just off Wilkinson Avenue is a small housing estate combining Wells Road, Baker Road and Pugh Road together. This snapshot sees, at no. 6 Pugh Road, Brenda Walton with a young Terence Walton in 1950. *(Terence Walton)*

Ash Street in Daisy Bank. The general gloomy 1950s view here has changed little over the years. What was once Perry's foundry is now a steel stockholders. The white building on the left, the former Commercial Inn, now serves as offices. Its smaller neighbour seen here, though now long gone, was once Roberts's sweet and general shop. The buildings following were known as the Bradsteads. Here for many years iron bedsteads were manufactured. Perry's too were noted for their high class bedsteads. *(Author)*

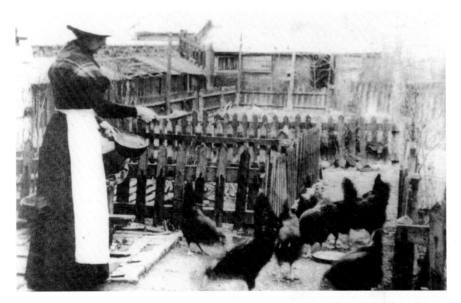

Annie Smallshire feeding her chickens in about 1903. The Smallshires resided at no. 62 Ash Street, Daisy Bank. Mr William Smallshire started his cabinet-making business in 1898, which continued for over 40 years. There was a workshop at Daisy Bank and a premises in Railway Street, Bilston, which closed in 1921. *(Roy Hawthorne)*

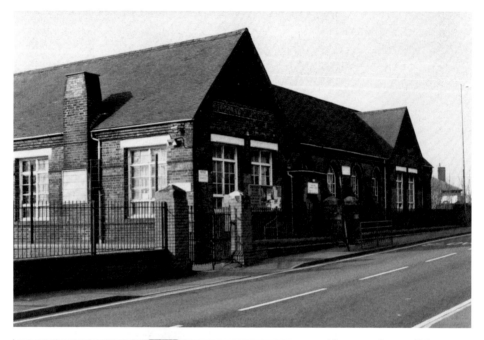

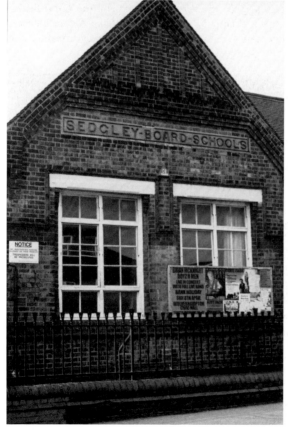

Neighbouring the Smallshire property comes the Daisy Bank school, sadly no longer in use as such, but it has found other uses as a library and community centre. *(Author)*

This gable end clearly states Sedgley Board Schools. The whole dates back to 1878. Daisy Bank then came within the Manor of Sedgley. Parts of Daisy Bank now come under Dudley, but the old school here now falls within the city of Wolverhampton. *(Author)*

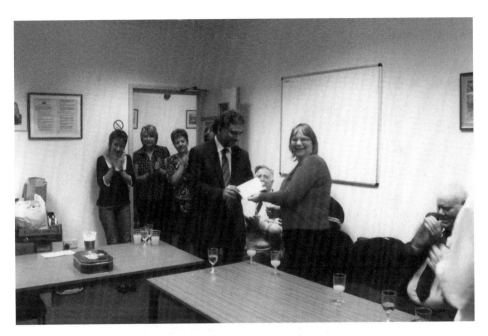

Here at Dr Lal's Surgery in Hall Green Street, the Patients' Voice Group, through their fundraising events, were able to donate to both the Air Ambulance and the Royal British Legion. In this photograph Dr Lal hands a cheque for £200 to Sue of the Air Ambulance, while applauding the event are surgery staff. Left to right: Kate Guest, Tracy Crowther and Janet Cartwright – on the extreme right is George Langford. *(Mike Horton)*

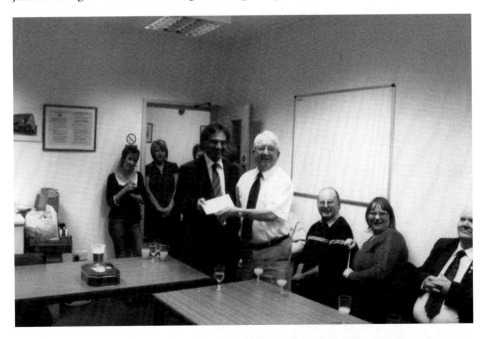

In this photograph Dr Lal hands a cheque to Gordon Fellows, Secretary of the British Legion, Lanesfield, also for £200, on Friday 18 December 2009. *(Mike Horton)*

Still at Dr Lal's Surgery, a farewell party is going on and goodbyes are being said to Nurse Debbie Elliott, who on retirement was moving to New Zealand. I'm sure everyone wishes her every happiness. *(Mike Horton)*

Not only was it a farewell party but also a hello party as we see Dr Lal and staff member Savita Kainth welcome new nurse Amanda Manley on Monday 1 March 2010. *(Mike Horton)*

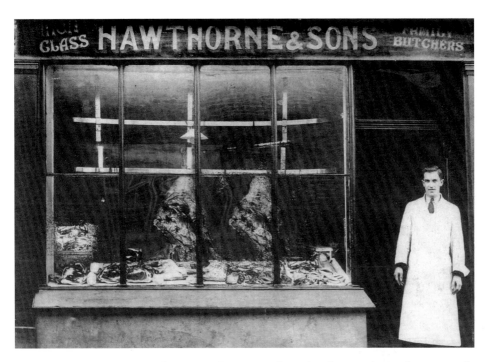

Still with Hall Green Street – this picture from 1931 shows butcher Frank Hawthorne outside his shop. Note the electric light hanging in the shop – quite an early example for 1931!
(Roy Hawthorne)

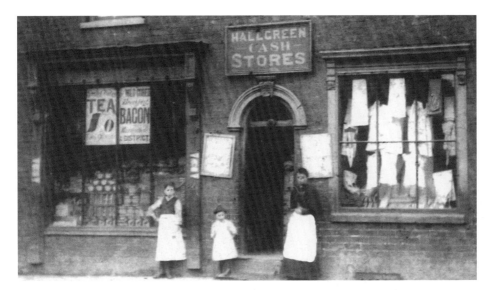

This is another early 1930 Hall Green Street scene. I wonder if anyone still remembers the shop? There were so many shops in the area from sweet shops, groceries, bakeries, clothes shops, cobblers and green grocers, to pawn shops. There was so much activity going on,, but following the slum clearance after the Second World War, not one shop remains today.
(Roy Hawthorne)

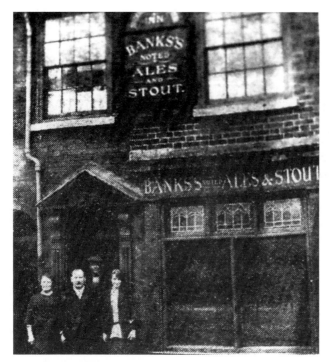

Who remembers the old Shoulder of Mutton Inn here in Hall Green Street? A lease was taken out on the pub in 1823, it was later bought by Banks's Brewery in 1876. In 1971 the pub was demolished and its licence transferred to the Fiery Holes pub on the Great Bridge road, where at present it is still trading. *(Express & Star)*

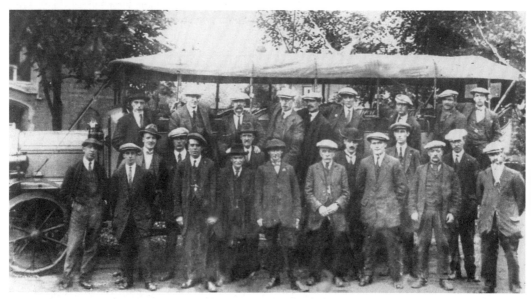

This wonderful old print, copied from a damaged original, dates back to April 1922. The group of twenty-four men pose in front of the period 'Chara'. Some of these vehicles had detachable backs, which could be changed for transporting goods. The speed limit was 12mph, which was an improvement on the speeds and distances horses could achieve. There are only two gentlemen identified: Mr Phillpots is on the front row second from the right and second from the left is Mr Vaughn. It is assumed the group, being all men, were either on a Sunday morning breakfast trip, or a Saturday afternoon visit to a local football match. *(Roy Hawthorne)*

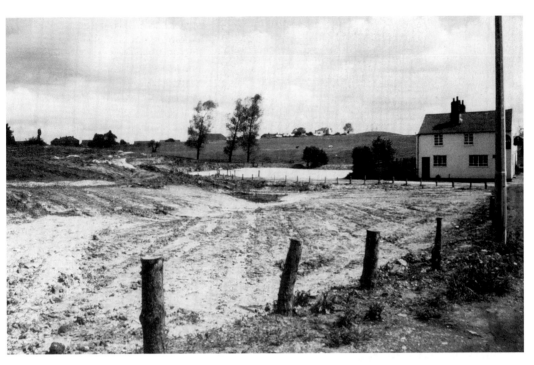

This landscape, seen here in about 1990, looking upwards from Brierley Lane West to Hall Green Street and the Methodist Chapel is now dominated by Hall Green Cemetery. The house, now secluded, was formerly a pub known as the Bricklayers Arms. *(Author)*

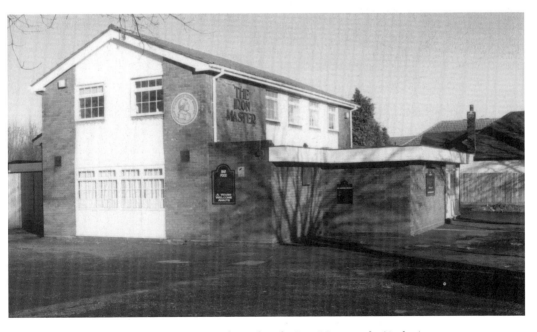

At the other end of Brierley Lane, at present disused, is the Iron Master pub. *(Author)*

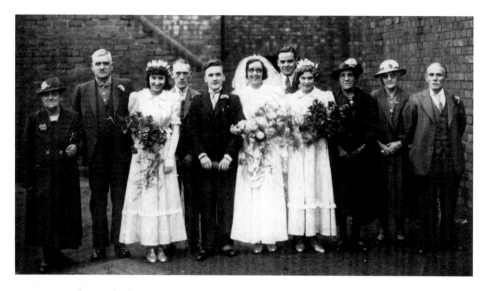

Moving on, the Methodist Church too is not without its weddings and this one is of Joseph Thomas and Phoebe Harper in 1941. Here we see, from left to right, Elizabeth Thomas, Samuel Thomas, Rene Thomas, George Thomas, groom Joseph Thomas, bride Phoebe Harper, Job Harper, Mildred Low (née Bunce), Mrs William Bunce, Mrs Cox and William Bunce. *(Roy Hawthorne – names supplied by Derek Dudley)*

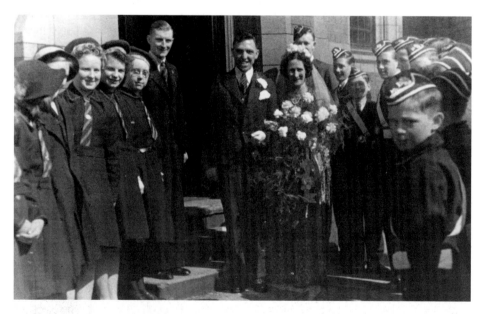

This next wedding is of Arthur Beddow and Floss Mason in about 1947. Seen here from left to right, the last two girls are ? Hale and Vi Fletcher followed by Jack Woodyatt, groom Arthur Beddow, bride Floss Mason and behind the bride Arthur Gough and Harold Dugmore. Arthur and Floss were both leading officers in the Boys' Brigade and the Girl Guides for many years. *(Roy Hawthorne – names supplied by Derek Dudley)*

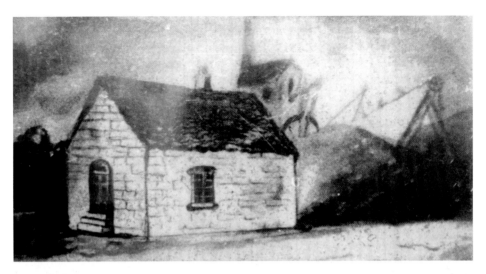

Briefly, the picture seen here had been lost for many years, then turned up as a printing block among the chapel archives. The building became known as 'The Cast Iron Chapel' the Holy Grail of all steel and iron structures since. The early Methodists around Hall Green begged Iron Master John Wilkinson to build them a chapel. At first he laughed at them, then later said, 'Yes, you can have your chapel' but stipulated that wherever possible it must be made of iron at his works. As a consequence not only were windows, pillars and pulpit cast but also bolts, nails, hinges, doorsteps, roof-ties and supports – and so the cast iron chapel was born, probably the first of its kind in the world. Afterwards Wilkinson was known to say, 'It was the most profitable speculation I was ever engaged in.' Note the cross on the door and the Whimsey engine in the background. All that remains of it now is the cast-iron pulpit. *(Hall Green Methodist Chapel)*

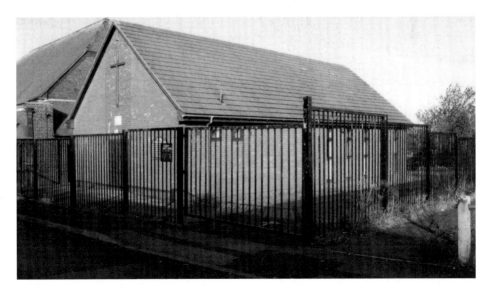

This is a view of the present Hall Green Methodist Chapel, looking so much like history repeating itself, the only differences being more windows, no Whimsey in the backyard and the cross now being over the door. *(Author)*

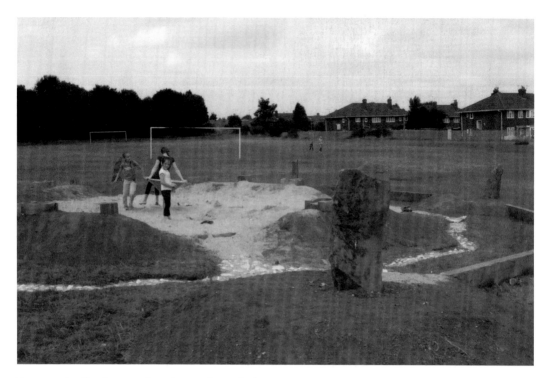

Just into Bradley Lane and to the south we find a normally busy sports field and a children's sand pit. *(Author)*

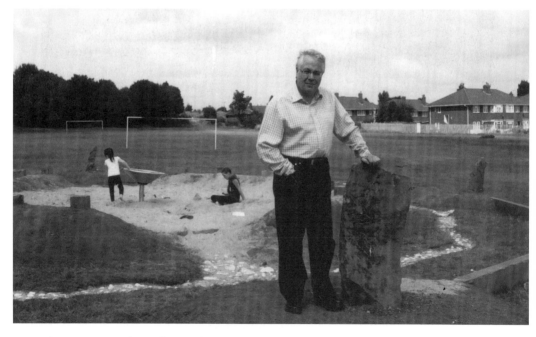

Here Adrian Pye poses alongside one of the standing stones surrounding the sand pit. *(Author)*

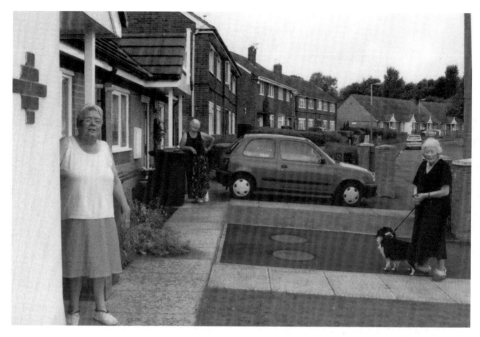

Here we see some of the ladies of the Rocket Pool enjoying a breath of fresh air. Nearest is Jan, next to the car is Marene and with her faithful dog Joey is Shirley. *(Author)*

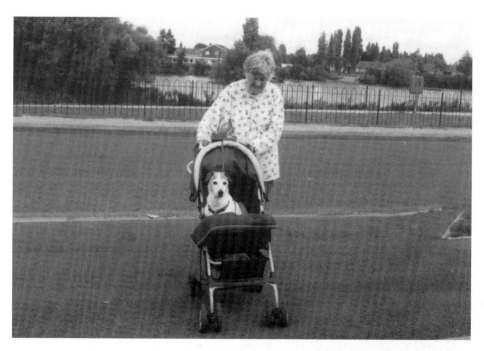

And here on their daily round is Joyce with Joe her faithful Jack Russell. Joe, completely off his legs, still enjoyed a breath of fresh air. *(Author)*

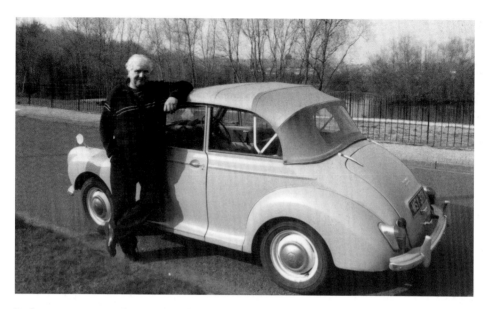

Perhaps my greatest fan (or at least a fan) of the Bilston, Bradley and Ladymoor books. Ray James, an ex-local Black Countryman now living near Wick in Scotland, travels all this distance in his faithful Morris Minor. Okay, he also pays a visit to his dentist and hairdresser while in the area. *(Author)*

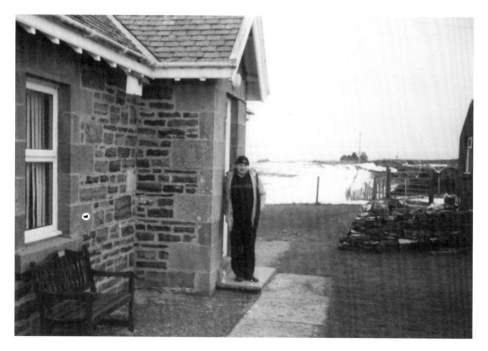

Here at home in Scotland he poses outside his ex-railway station home. Yes that is snow in the background. I do hope that he will enjoy this seventh book even more. *(Ray James, with thanks to his farmer neighbour for taking the photograph)*

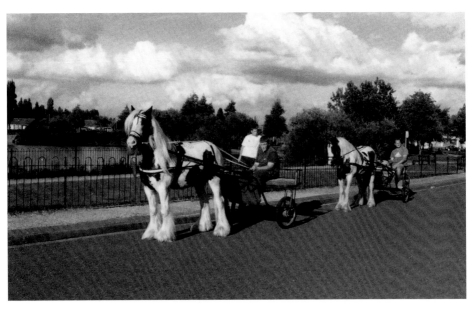

Still with the Rocket Pool, there is no shortage of visitors of one form or another as proven by these twin horses and traps. *(Author)*

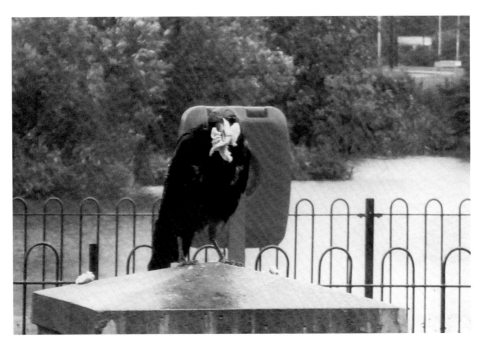

And of course there is no shortage of wildlife here as this crow shows. They have been much maligned over the years so they are now timidly shy. Their food intake is quite small and they often allow other birds to share just a half round of bread or other tit-bits. *(Author)*

This next picture takes us to the Great Bridge Road and way back to the 1920s. Here at the Travellers Rest customers gather outside to pose for this shot. Just a few are known – on the back row, from left to right, are George E. Grew, -?- and Mr Grew. On the front row are -?-, Mr Bailly, -?-, -?-, Mrs Bailly, Mr Mansell and Mr Davies. The Bailly family were the licencees. *(Don Reynolds)*

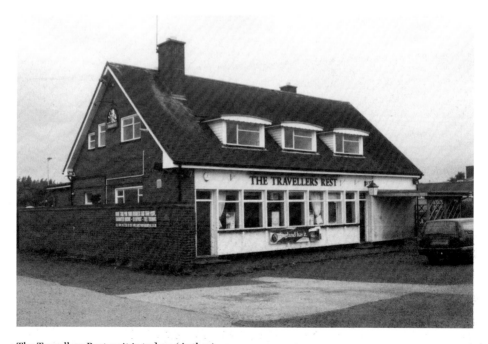

The Travellers Rest as it is today. *(Author)*

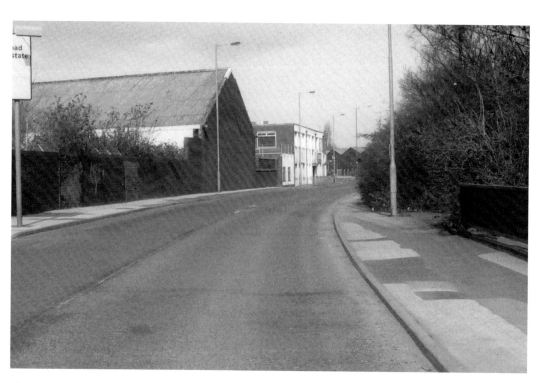

The Great Bridge Road and Bull Lane had for many years been deeply industrialised. The last enterprise to close up was Wesson's Ironworks in Bull Lane. Where once there was so much activity all is now so quiet and peaceful as both these pictures show. *(Author)*

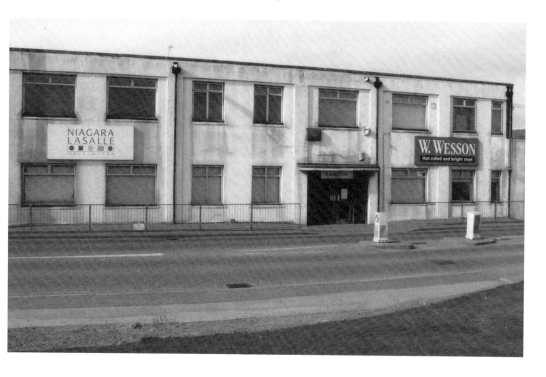

On the Great Bridge Road the victim here was Thompson Brothers. This picture shows a forlorn scene where once huge oil and milk tankers were made. *(Author)*

The building in this other Thompson scene was where smaller products were manufactured. Note the works canteen on the right of the picture. The whole is now fast becoming a housing complex. *(Author)*

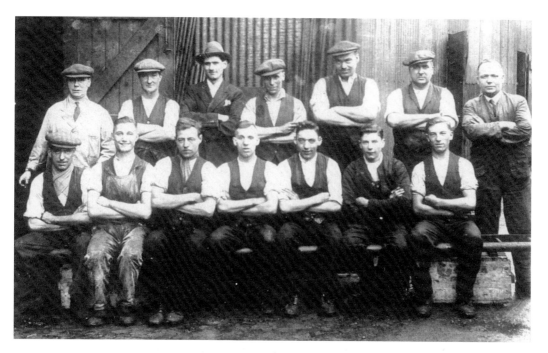

These two photographs show Thompson Brothers employees. The top group go way back to the 1920s and the lower group to 1935. There is always the off chance that some will be recognised, most being Bradley folk.

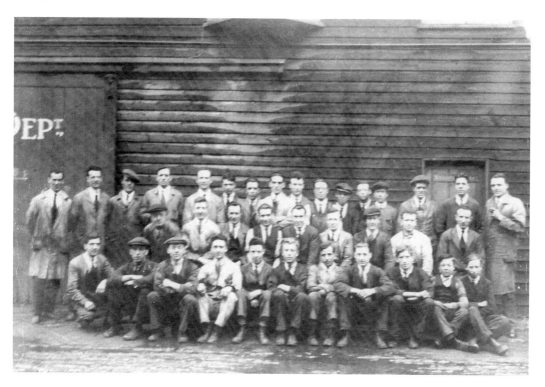

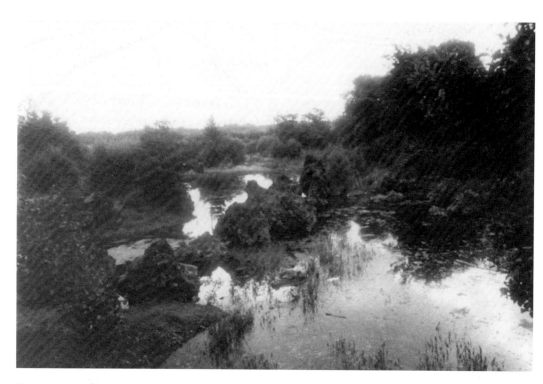

Lying more or less between Wesson's and Thompson's were the Moorcroft furnaces. This picture shows what is left of it. Slag-heaps and collieries abounded here as the map opposite clearly shows. A near disaster took place at Moorcroft in the early nineteenth century, reminiscent of the Chilean mining accident in 2010. An account of the accident from a contemporary source is reprdouced opposite.

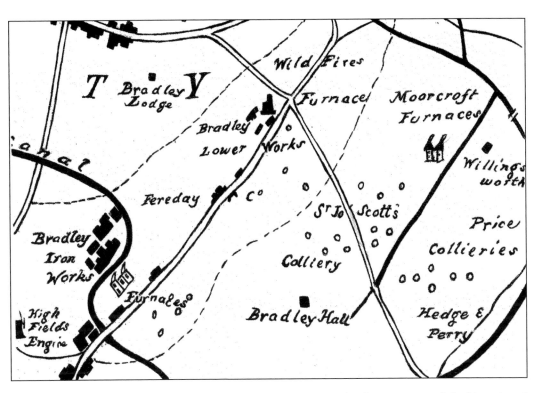

A map showing the furnaces and collieries in the area. Scott and Foley were one of the biggest coal producers in the area in the early nineteenth century.

At one of the coal pits belonging to Messrs Scott and Foley, the ground, which is sandy, took a vent in the workings, which to all appearances completely choked them up, trapping nine men and a boy working there. It was conjectured that due to the force of the confined air at the back of the workings, the sand could not completely fill up the cavity, there being a chance that the men were still alive. Around the clock, shifts of men were employed to make a passage to the desired and anticipated spot where the hoped for surviving men were. After seven days of digging the workmen were responded to, within a few inches of the cavity, the first small penetration was through the coal to prevent too great a rush of air upon their nearly worn out constitutions. In a short time eight men and a boy were found alive. They were immediately fed with gruel. The ninth man was lame and could not run fast enough to avoid the rushing sand.

The vent happened on 17 April 1813. (*An Historical Account of Bilston* by Joseph Price, 1835)

Within easy reach and opposite Thompson Brothers once stood what was Willingsworth Hall, as shown here. Its origins appear to be in the seventeenth century and came within the Manor of Sedgley. It was mainly the residence of the Parkes family of Wednesbury. The last resident here was Bridget Forrester, according to the 1851 Census, and she was a widow aged 52 and listed as being a farmer. In the 1871 Census there is no mention of the hall – only the ironworks there. *(The Blackcountryman, vol. 16 No. 4)*

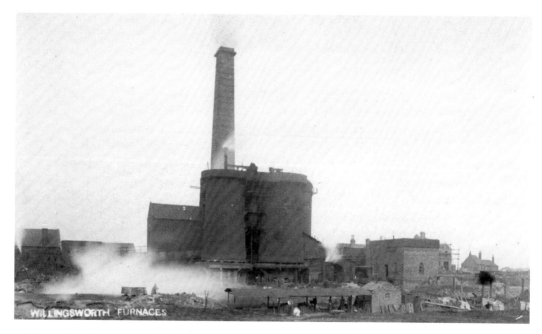

While on the subject of Willingsworth Hall, here is a view of its neighbour Willingsworth furnaces. It is said the last cast was in 1919, but the furnaces remained, though unused, until their demolition between 1939 and 1945. I remember them well on the odd train journey to Birmingham and also the polluted land opposite on the other side of the railway line. The site is now occupied by the Royal Society of Arts academy at Tipton. *(Ian Bott)*

The building seen here lies on the Bilston Road opposite the academy, although it is now empty, neglected and well-hidden within a canopy of trees. In recent years it went by the name of Ivy Dene, though much earlier was known as 'The Hoo Arms' public house, so named after the Hoo family. From ancient times, the family lived at Bradley Hall, which was situated in the locality of Meldon Drive in the Rocket Pool area. Unfortunately no likeness of the hall is known to exist. *(Adrian Pye)*

This is a view looking up the former Bradley canal locks from the Great Bridge Road. The top right corner shows the line of the old Bradley canal and the Rocket Pool beneath, all very close to where Bradley Hall stood. It was also the site of the Dairy House and Tup Street Farm. The latter was occupied by Mr Thomas Wright, who was the engineer to John Wilkinson. *(Author)*

This scene shows what was once known as Tup Street Bridge, though it has been long since levelled to give easy access to Bradley Lane. Modern street maps still record the spot as such. *(Author)*

THREE

LADYMOOR

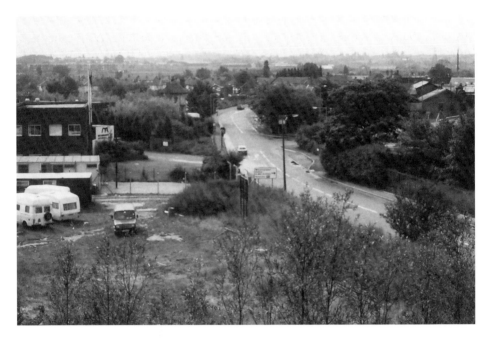

This shot from about 1980, taken from the former Coseley Road railway station, covers more or less Broadlanes. Where the caravans are was once a lovely meadow of buttercups and daisies. Pitt's Cot (see page 110) lay on the opposite side of the road and nearby stood Bricklayers flour mill. In his *The Story of Bilston*, on page 9, John Price asserts, 'A proof of the rural character of the town was its possession of at least one watermill and one windmill. From a deed of the reign of Richard II 1378 we find that one William Poort was priest of Bilston. For in the deed Thomas Robyns and Juliana his wife do give to William Poort priest of Bilston, one messuage, one water-mill etc.' Near to the distant end of the road was where a German bomb dropped on four houses. *(Author)*

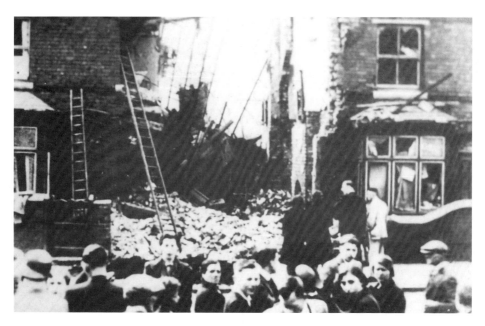

This is an oft-published picture of the aforementioned bombing in the village on 20 August 1940, when a small terrace of four houses received a direct hit, killing two residents. Two known figures among the onlookers are, on the extreme right, Mr Harry Philips who kept a green grocery, while on the opposite side of the road next to the George and Dragon Inn (the Clog), the young man standing close to Mr Philips and looking into the camera is Harry Eccleston, who achieved some fame as the designer of the last denomination of banknotes for which he received an OBE. Many of his local sketches are well known in the Bilston, Bradley and Ladymoor series. Sadly Harry passed away on Thursday 29 April 2010. *(Express & Star)*

This is how the former bombed site looks today. *(Author)*

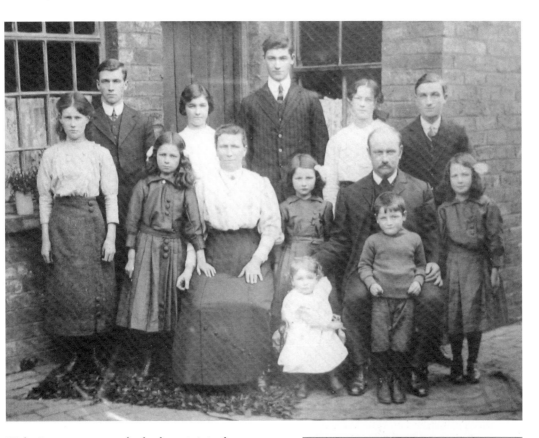

Withy Lane, once a popular back route into the steelworks, was also a nice little residential area. One family living there were the Bakers, including Robert Baker whose artistic talents have been featured in earlier volumes. Here is a wonderful Baker family photograph from about 1915. All their names are known but not in what order. On the front row are parents Rebecca Ellen (née Blaze) and Alfred Snr. Others are John Edward (born in about 1892), Thomas Adam (1893), Sarah Ann Louisa (1896), Elizabeth Ellen (1898), Louisa (1900), Florence (1903), Alice (1905), Maud (1908), Robert (1909) and Bertha Annie (1912). Alfred Snr, to my knowledge, was the engineer at the former Porkets Bridge pumping engine, Darlaston Lane. *(Dorothy Turley)*

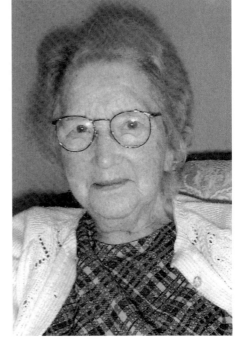

This is a lovely photograph of Alice Winchurch (née Baker) in her later years. She passed away on 15 January 2004. *(Dorothy Turley)*

Another nice little Ladymoor group taken on Ramsbottom's field with the Highfield housing estate in the background in about 1950. Here we see at the back Mary Bunce. On the front row, left to right, are Margaret Bunce, Barbara Ashmore and Mary Draisey. *(Fred Bunce)*

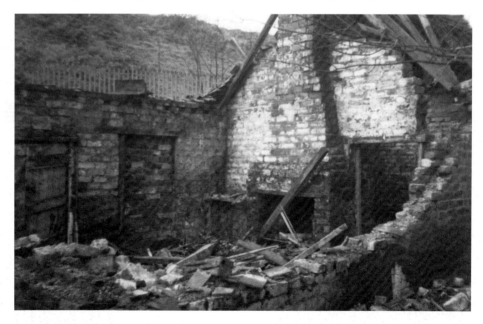

What looks an irretrievable mess when photographed in about 1988, Pitt's Cot now stands proud as part of the Black Country Living Museum. It seems not so long ago that I used to go there and spend an hour with the Pitts, the family being customers at my parents' pub, the Brickmaker's Arms, a little further into the village. Note the railway embankment in the background that carried necessary materials into the steelworks. *(Ian Bott)*

A lovely picture showing Mrs Irene France
with daughter Dorothy outside their cottage
home opposite the Ladymoor schools in 1925.
(Dorothy Davies, née France)

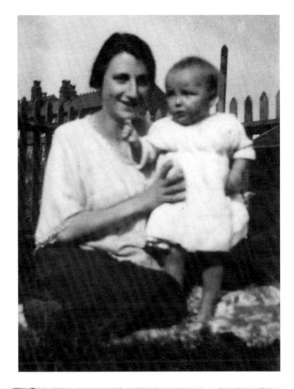

Another picture of Dorothy taken with
neighbour Gwen Lang (née Tyre) in 1935. The
Frances' cottage can just be made out in front
of the school. *(Dorothy Davies)*

This is a view of the Ladymoor school in the primary stages of demolition in about 2002. *(Author)*

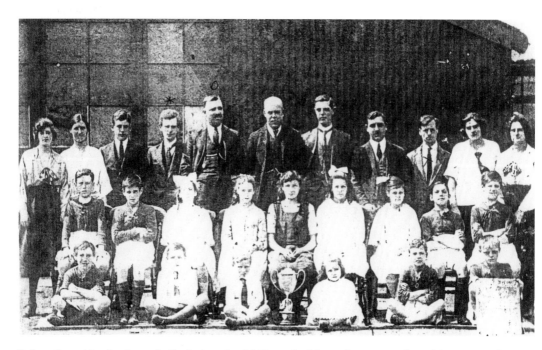

Before the said school was built during the 1920s, a building of corrugated steel known as the 'Tin School' served the local area. Dome of the teachers seen here made a successful transfer from the old to the new. Back row, left to right: -?-, -?-, -?-, Mr Hopcutt, Mr Moody, Mr Wright, -?-, -?-, Mr Millard, -?- and -?-. *(Iris Woodings)*

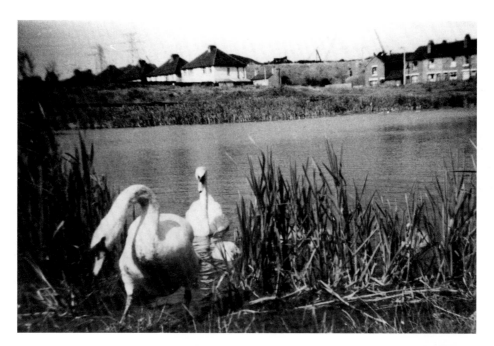

This is a view of Ladymoor Pool as it once was. The houses on the right of the scene were known as Chillington Terrace. *(Joe Richards)*

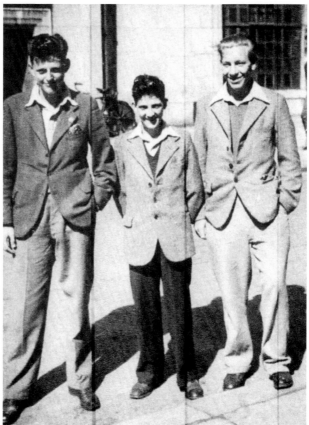

Three of the village lads pose here in 1946. We see, from left to right, Reg Turton who lived in Chillington Terrace as did Bill Turton (Reg's cousin) after his mother died, then Fred Bunce from the Broadlanes end of the village. *(Fred Bunce)*

Two lads explore the canal and its surroundings at Highfields in 1988. The former Boat Inn dominates the scene. The lads – twins from Wednesbury – are David (on the left) and Christopher (on the right) Bott. *(Ian Bott)*

In the same spot but twelve years earlier we see these open or sludge boats tied up along Baker's coal wharf. They usually had some primitive dredging device to keep the waterways clear – the sludge was emptied around the Ladymoor Pool. In the earlier days it was not unusual to see women picking coal on the site. *(John Piper)*

Here is an incredible picture of beauty and the beast – beauty being little Brenda Willis happy on her push pony among the flowers, so innocent of the Capponfield beast that stood just yards away, separated only by the canal. Its roar, however, was now silent in this photograph from about 1935, the facility not having been in use since 1929. *(Brenda Bunce)*

Brenda, now quite grown up, poses with husband Fred Bunce on their wedding day – New Year's Eve 1955 – at Christ Church, Coseley. Fred at that time was in the Royal Navy and had just ten days' leave to sort it all out. *(Fred Bunce)*

Here at the wedding reception Fred and Brenda pose by their three-tier wedding cake. *(Fred Bunce)*

Fred, attached to HMS *Collingwood*, had just finished a twenty-two-month electrical course when this shot with Brenda was taken in October 1956. *(Fred Bunce)*

If anyone could turn a pile of junk into a work of art it was Harry Eccleston. Mr Jones's saw mill in Highfields was never the tidiest and with Harry living close by, I suppose the temptation to do a sketch of it became a priority. In the background note the line of the old railway and the tower of St Leonard's Church. *(Harry Eccleston)*

A last look at Ladymoor Pool in its daisy-covered surroundings, 1980. *(Author)*

A 1980s view overlooking Ladymoor and its former New Coseley or Turley's furnace site. Note the slag heap remains to the right of the picture. During the 1980s the whole site was registered as a Site of Special Scientific Interest, owing to the diversity of rare plants growing here, but today the site has been taken over by ever encroaching trees. *(Author)*

In this winter close-up we see how the site looks today. *(Author)*

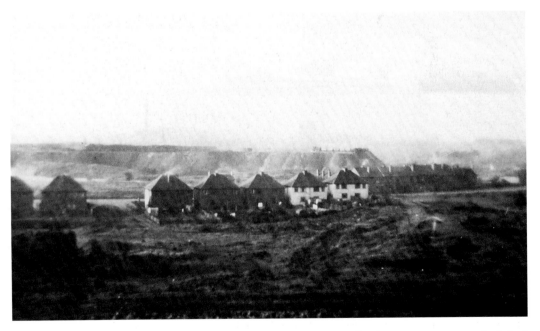

This is another earlier shot of the furnace site from the 1940s; the slag heap is now seen to the left of the scene. Note the ever-encroaching steelworks tip in the background. *(Andrew Barnett)*

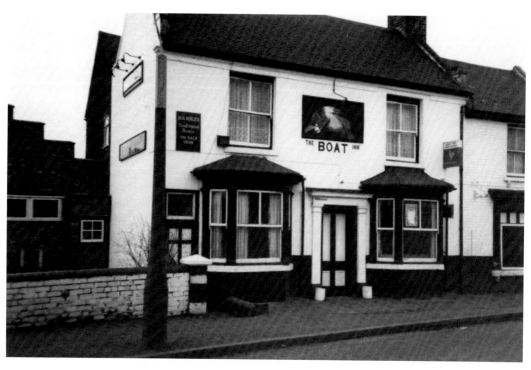

A little touch of Deepfields showing the former Boat Inn as it stood in Havacre Lane in 2010. *(Author)*

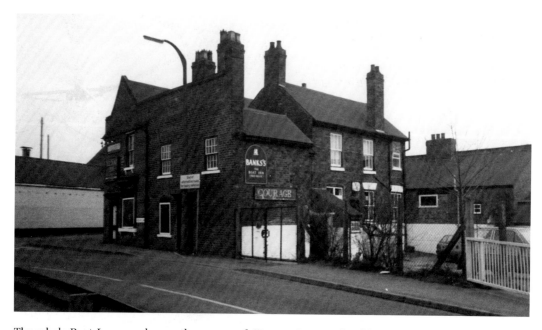

The whole Boat Inn complex on the corner of Havacre Lane and Biddings Lane once included a post office and snack bar. The fence seen to the right in this 2010 photograph overlooks the Birmingham Navigations Canal. *(Author)*

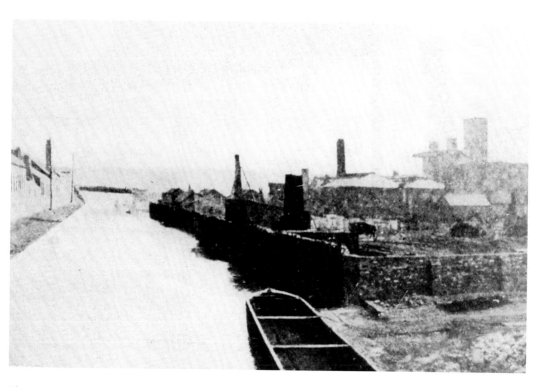

This scene from the canal bridge in about
1910 shows, on the left, part of the old
Cannon Works. In the distance on the right
note the former Priorfield or Whitehouse
furnaces. The immediate boat scene and its
wharf once led to a small foundry run by
Mr Horace Wilkinson. *(Black Country Society)*

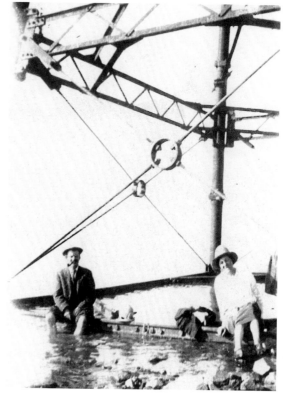

This picture sees Mr Horace Wilkinson (who
had the foundry mentioned above) and his
wife Violet Ethel enjoying a well-earned break
at Weston-super-Mare in 1925. *(Iris Woodings)*

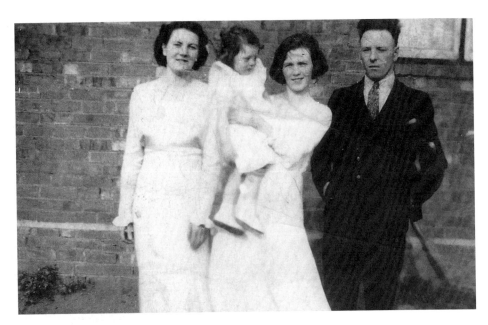

Here we see sisters Winnie Wilkinson, Ada Cox (holding little Iris) and husband Bill Cox.
Ada and Bill's wedding was recorded earlier on page 42. This photograph was taken on King
George V's Silver Jubilee in 1935. *(Iris Woodings)*

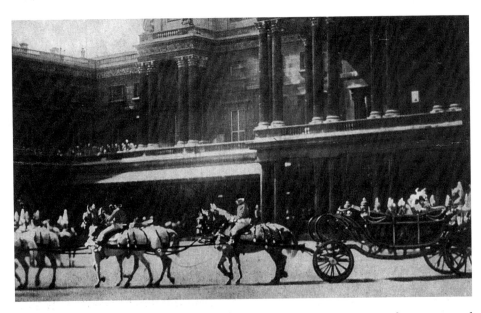

This is a postcard scene of the Silver Jubilee Day in London, 1935. Note the open-topped
State Landau carrying King George V and Queen Mary. It was also the same Landau that
carried Prince William and his bride Katherine from Westminster Abbey to Buckingham
Palace on 29 April 2011 as the Duke and Duchess of Cambridge. The carriage, dating to
1902, was intended for King Edward VII's coronation but due to illness another coach was
used instead. *(Iris Woodings)*

A charming 1931 picture of Ada and Winnie Wilkinson, Ada on the left was then seventeen years old while Winnie was fifteen. *(Iris Woodings)*

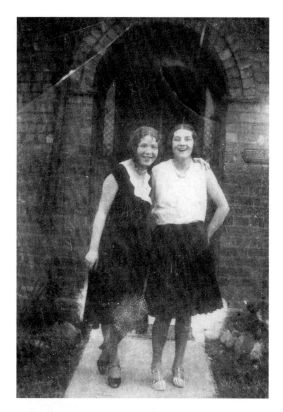

Here are the sisters again in 1931 to give you an idea of the fashions of that time. First is Ada and then Winnie. *(Iris Woodings)*

A lovely picture of Iris Cox aged six years, taken on 14 December 1938 at Ladymoor Infants School. *(Iris Woodings)*

The wedding of George Woodings and Iris (née Cox) in August 1955. From left to right we see the bridesmaid and page Madge and Terry Wilkinson, Mr and Mrs Woodings, John Woodings, George Woodings (groom), Iris Woodings (bride), Ada and Bill Cox and Doreen Barratt (bridesmaid). *(Iris Woodings)*

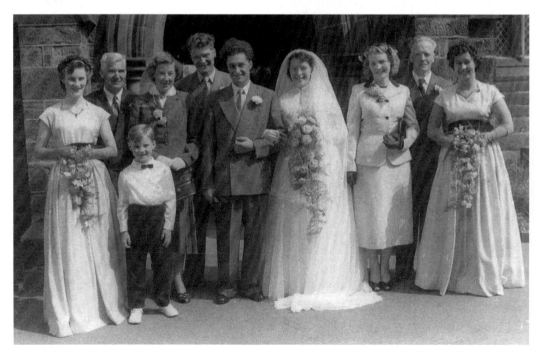

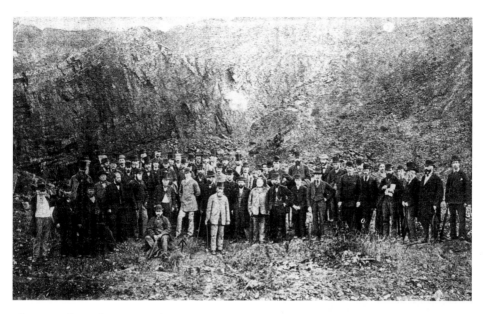

This scene from about 1896 shows a group of coal mine owners posing against the backdrop of the famed 30ft coal seam, seen here exposed at Woodsetton, Coseley. Noted here are the Earl of Dudley, seen standing next to the seated man, and Mr Samuel Wilkinson, father of the aforementioned Horace Wilkinson, is on the front row, fifth from the right. *(Iris Woodings)*

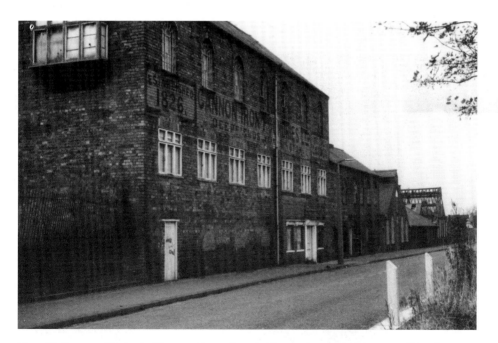

The old Cannon Works in Havacre Lane, Deepfields, in about 1950, so noted for their gas cookers, etc. The site is now a housing estate. The Boat Inn can be seen in the distance. *(The Black Country Society)*

The nearest pub to the Boat was the Swan Inn, shown here in Darkhouse Lane, just off Havacre Lane. The pub was more or less surrounded by the Cannon Works which had taken over most of the local area. The property adjoining the Swan Inn was a sweet and grocery shop run by Mrs Ball. The start of the houses seen on the right were railway properties, the LMS railway line running just to the rear of them.

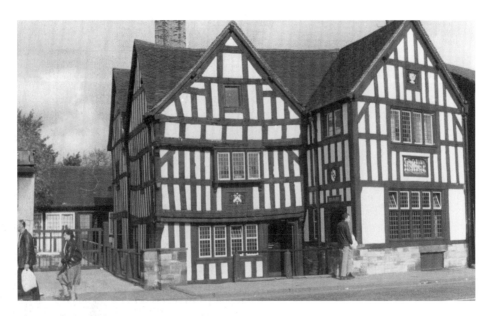

The Greyhound Inn.

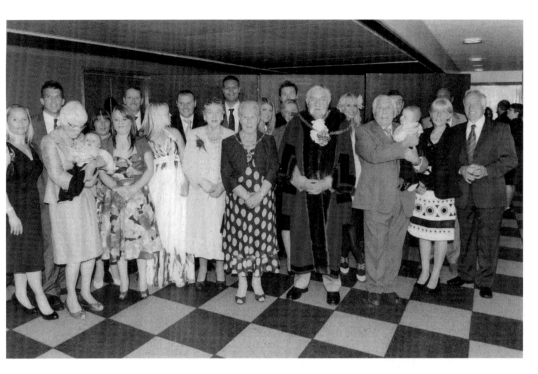

Here the new mayor and mayoress,
Councillor Bert and Mrs Kath Turner, pose
with Lord and Lady Bilston and sister Beryl
Nash, who is standing next to the mayoress.

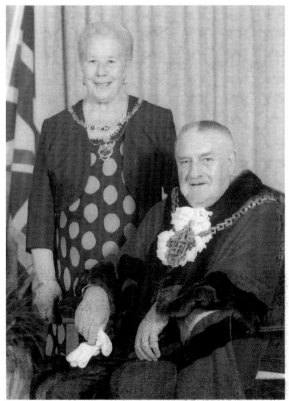

Here the mayor and mayoress sit for a
formal photograph.

ACKNOWLEDGEMENTS

I am most grateful to the following:

Andrew Barnett, Ron and Ruth Beards, Alma Boden, Ian Bott, Ken Brown, Fred and Brenda Bunce, Ivy Clarke, Dorothy Davies, Derek Dudley, Harry Eccleston OBE, Arthur Edge, John M. Hammonds, Roy Hawthorne, Jan Hayward, Iris Hazlehurst, Stan Hill, Mike Horton, Harold and Pauline Humphries, Ray James, Brenda Mason, June Parkes, J. Willis Pearson, Joe Perks, John Piper, John Price Printers, Joseph Price (1835), Adrian Pye, Don Reynolds, Rick Reynolds, Joe Richards, Kathleen Skowron, John Smith, John (Jack) Southan, *Steelworks News*, John Thompson's Brochures, Dorothy Turley, Bert Turner, Peter Unitt, Terence Walton, Alan Webb, Brian Webb, Linda Webb, Lou Willis, Iris Woodings.

Further acknowledgements are due to the staff of Bilston Library, Mr Terry Calloway, Lyn and Anita Cooper, *Express & Star*, Mr Pat McFadden MP, Mr Percy Simmonds, staff of Wolverhampton Archives, and special acknowledgements to the Black Country Society and to all who in the past have donated photographs for the *Bilston, Bradley & Ladymoor in Old Photographs* series. Also the Fotostop Shop in Roseville.

Thanks also to Adrian Pye for undertaking the proofreading of this seventh selection. Every effort has been made to contact copyright holders of photographs.

All author's royalties from the book are to be donated to Compton Hospice.